Fantasy Postcards

Fantasy Postcards

William Ouellette

with an Introduction by Barbara Jones

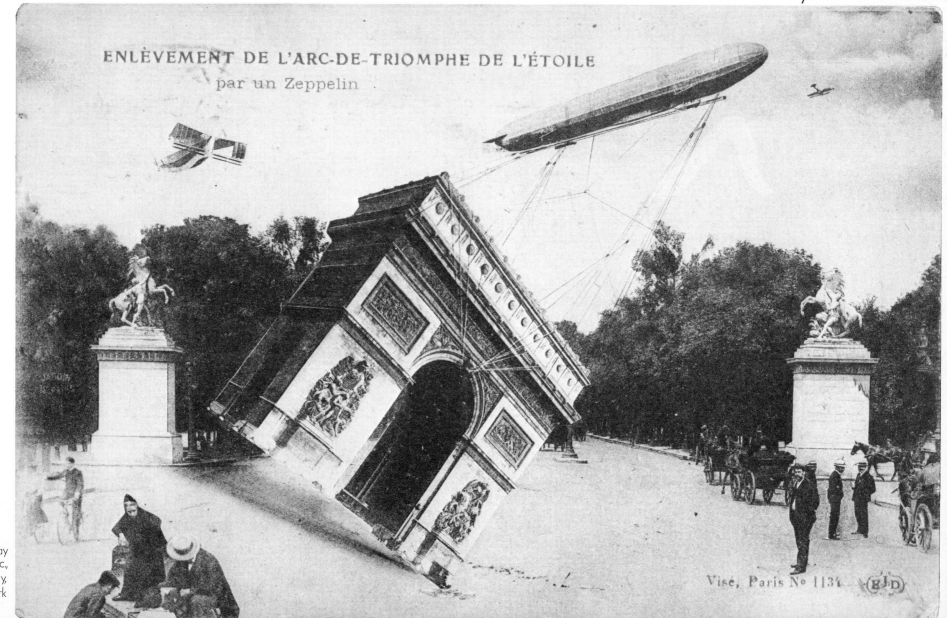

ENLÈVEMENT DE L'ARC-DE-TRIOMPHE DE L'ÉTOILE
par un Zeppelin

Visé, Paris Nº 1134

Doubleday
and Company, Inc.,
Garden City,
New York

ISBN: 0-385-11230-0 (paperback)
ISBN: 0-385-11175-4 (hardcover)
Library of Congress Catalog Card Number 75-7893
All rights reserved
Printed in Great Britain
First Edition in the United States of America

This book was designed and produced by
London Editions Limited
30 Uxbridge Road London W12 8ND

My thanks are due to Bamforth & Co Ltd; Leader Printers, Wildwood Crest, New Jersey; Raphael
Tuck & Sons, Warminster, Wiltshire; and Valentines of Dundee Ltd, for their kind permission to use
cards which are in their copyright. Please see the Notes for further details.

PUBLISHERS' NOTE: Owing to the age of the cards and their extreme rarity, it has not in every case
been possible to reproduce from perfect specimens. This is particularly apparent where photographs
have deteriorated physically. In other cases, small tears, scuff marks and fading have taken away from
the cards some of their pristine glory. But in the interests of authenticity they have been reproduced
here as they are, without retouching their defects.

Contents

To the anonymous artists and craftspeople
who gave us these images.

An Introduction by Barbara Jones

'All is but fantesy and enchauntmentes', wrote the second Lord Berners in the sixteenth century. The pretty word *fantesy* was new in English, and meant 'a phantom; an illusory appearance'. It was part of the cascade of inventions in the golden century of the language when the Dark Ages were over, and all dead and living words were there to plunder and make new.

But fantasy itself is necessary to man, and it is as old as history. The arts have always both drawn from it and created it; sometimes it dwindles and is discouraged as it is in Russia today, except in the simplest shapes of heroic glorification. But it will not die.

In painting it has had marvellous pinnacles of invention like the work of Hieronymus Bosch and Pieter Breughel the Elder who peopled their almost ordinary landscapes of rocks and ruins, not only with normal men and angels, but also with hundreds of new inventions, living bagpipes, jugs and knives, half-birds, part-butterflies and quarter-fishes, mingled and translated, both beautiful and sinister. This ambivalence haunts all fantasy.

But powerful imagination is not enough for pictorial fantasy; it must convince – we must instantly *believe* in the fish on human feet – and so it must be well done, painted by a skilled artist. The best pictorial fantasy was always expensive, and was not to be had on a popular scale until the invention of printing, and even then for four hundred years the only things within reach of the poor were the prints and broadsheets illustrated with coarse wood-cuts, carrying the message of the fantasy but little conviction.

Then in the 1860s, good illustrations became available for everyone with a penny to spare: by *engraving* wood, instead of cutting it, an artist's finest penstrokes could be reproduced in thousands of daily, weekly and monthly papers and cheap books. Popular publishing exploded, and fantasy, especially in children's books and games and in advertising, exploded with it. At the same time chromo-lithography was also booming. This technique reproduced paintings by printing a series of colors on top of one another, each from its own polished stone, and reached extraordinary heights of richness and brilliance, especially in Germany, where the new aniline dyes were first used in the inks. Chromo-lithography cost more than black-and-white, but it was still cheap enough to take a picture into the home of everyone above the breadline.

At first the subjects were grander than on the black-and-white cards – a portrait of the Queen or George Washington, reproductions of famous or sentimental paintings, technically magnificent – look at the bloom on those grapes or the tear about to brim over! But there was a certain pomposity, a dullness, art was to be reverenced: printing was ready for the freedom of the postcard, though there was a long delay as postal regulations and systems were gradually adapted to meet the new demand.

This was not because there was anything totally new about the postcard to be invented: decorated trade-cards had been in use for a long time, and decorated

writing paper came in during the eighteenth century; but letter-writing was for the rich – few people could read or write, and postage and paper were expensive. By 1840, the new envelopes were decorated like the paper and the penny post was introduced in England, but not until the international Great Exhibition at the Crystal Palace in 1851 were attempts made to sort out the chaotic state of postage generally; no two countries had the same rates or regulations. Reform hung fire, while the postcard made its slow and uncertain start.

Several countries claim to have invented it, definition is vague, dates unsure, but as far as I know: first copyright, Philadelphia, USA, 1861; first official cards at half letter rate, with pre-printed stamps, Austria, 1869. There were no pictures on them yet, but almost three million were sold in the first three months. In 1870, the France-Prussian war gave Germany the chance to send the first airmail cards by balloon from Paris, and in Great Britain the first halfpenny post was introduced, for postcards only, while Messrs De La Rue produced the first ones to be pre-printed with the stamp. They printed in sheets so that the reverse could be printed before cutting and pictures began to appear. Sometimes they were pictorial cards made by the printers for advertisers to use as trade-cards and sometimes the printers published them directly. The first known card printed in color was published the same year in time for Christmas

CHRISTMAS GREETINGS
When the ruby-eyed holly-bush gladdens the sight,
And the pearls of the mistletoe sparkle with light,
Think of one whose fond heart with affection is beating
Who now sends with love this new Postal Card greeting.

The verse is surrounded by a suitable border of berries; all is predictable and calm. Underneath, though, are the words JOHN S. DAY. LITHOGRAPHER & PRINTER . . . The postcard had briefly met the process, but after this there was a long quiet hush, for there were problems.

At last in 1875, the general Postal Union (later *Universal*) gave a standard rate between all member countries, with postcards half price. Adhesive stamps were not yet allowed on cards, and only the name and address might be written on the stamp side (or, to postcard collectors, the back). No pictures were officially allowed for ordinary sale in Great Britain or America, but things were easier in Germany, Switzerland and Austria, and there the first little views in one color on hotel advertising cards developed by about 1890 into bolder views, and then quickly into the *Gruss Aus*, or *Greetings From*, or *Souvenir De* cards that by the end of the century were being printed, or chromo-lithographed, in Germany and Switzerland for countries all over the world. They are some of the most beautiful postcards ever produced: a group of little views vignetted or framed, linked in scrolls, ribbons and flowers, presents the town by moonlight or by day, with a girl, or a zoo, or a climber waving a handkerchief, even a factory. If there is a lake near the town, the letters of its name may be half-submerged in the water – ingenuity never falters.

In the nineties, America and Great Britain shed more regulations, the adhesive stamp was allowed and publishers could print their own cards, but still the rest of the stamp side was everywhere for the address alone. The designer of the front had to make the card pretty enough to buy while leaving enough space for the

message beside the picture. Sometimes there was almost no space at all, and frustrated writers used very fine nibs and wrote all round and in every corner. But most people didn't want to write a lot in any case, and the way was clear for the holiday postcards from abroad, and postcards to and from everywhere for Christmas, New Year, Easter and birthdays. During the 1900s all the countries began to allow the message to split the back with the address, and after more than thirty years the front of the postcard was free.

The postcard had itself freed correspondence with the first cards in Austria. The privileged stranglehold of the articulate and the well-to-do on letter-writing was broken, cards and their postage were cheap and at least a greeting, *X X X*, was easy for anyone who could write a name and address. Delivery was fast and reliable. You could post a local card in the morning asking a friend to tea at four that same afternoon; the friend might arrive on that other liberator, the bicycle. There were cards that made it easier still, with the ready-scrawled starter in imitation handwriting – 'You really must come', 'Just a line to tell you', or a blank clock-face.

And the postcard had also released to thousands the pleasure of collecting. Nobody could bear to throw away the early *Gruss* and view cards, and miraculously, the size had settled to 14 × 9cms. Soon special albums could be bought, but the poorest collector could keep the cards in a shoebox; they were the first small pretty things that could be collected in hundreds without much money, or a cabinet, or the mess of a scrap album – neat, clean, all alike, and all enchantingly different.

The most delightful cards generally came from Germany, which had the best printers in the world, not only good lithographic draughtsmen who could break down a painting into the seven or eight colors it could best be printed in, and draw each one precisely, but also skilled men on the presses who would place sheets of card on to the seven or eight stones in perfect register. Germany also had a long tradition of fantasy allied to print – look no further than Dürer – and, as the cheap china warehouse of the world, producing vast quantities of souvenirs and tea-sets, she was geared to marketing popular goods. Millions of lovely cards went out from German printers to publishers abroad, often stock designs with new words, and millions more were designed in other countries and sent to Germany for printing. Many were given the extra richness and realism of embossing, perhaps with a scrap of colored silk and maybe gilding as well: it made a Christmas card or a Valentine more like a tiny present.

For chromos in quantity, Germany was supreme, but other countries had fine printers too, and other processes. France specialized in collotype, which reproduced photographs and the photo-montages of fantasy with exquisite clarity and detail; for the camera and collotype beat the draughtsman and lithographer at showing a crowded London street with the spokes of every carriage wheel and every shop name clear, and also for such achievements as the 'Removal of the Arch of Triumph from the Etoile by a Zeppelin' on the title page.

Photographic prints were used too, especially for recording exciting local events – a balloon race, a bazaar, a tram disaster, or a fire. Cards were on sale in the streets within hours, sometimes in series from first flames to wreckage. On the back of a fantasy card the words 'A Real Photograph' were obviously seen as a guarantee of hard fact, but the camera was used twice . . .

Postcards were available everywhere, from the corner newsagent or the railway station to the slot machine on the pier or the street-vendor, from big cities and large hotels or from tiny villages – literally from the top of the Eiffel Tower to between the paws of the Sphinx. A French card of 1904 gives these statistics: 'Germany holds the record of correspondence by postcard, 1,013,500,000 cards, France, 600,000,000; Japan, 453,000,000; Austria, 250,000,000; Belgium, 55,000,000; and Switzerland, 43,000,000.' Most of the early millions showed real-life people and places: coronations, exhibitions, village pageants; heads of state, bishops, cricketers, dwarfs; Sarah Bernhardt, Buffalo Bill, Camille Clifford, an amateur pierrot; Milan Cathedral, the Flat Iron Building, a post office, a cottage; *Mona Lisa, The Stag at Bay, The Slave Market.*

Above all, these were views, and we are not often interested in them now unless they have some accidental quality of surrealism, for we have seen it all on television. In 1900 the world was coming through the letter box on postcards. They were looked at with wonder as we cannot look – we have lost that innocence – but such simplicities as the events and places of the world did not satisfy for long even in 1900, and the vigour and complexities and sophistications and dreams that are the material for all the popular arts descended on the postcard and didn't begin to lose their grip until 1914.

The delicate balance between the fine and popular arts is never resolved; sometimes they run near as they did in Regency England, sometimes far apart as in the golden age of the postcard. Always there are exceptions, influences, and puzzles, but one definition of the popular arts remains firm, I think: they are the things that people make for themselves or that are manufactured in their taste. Most of the popular arts are complex and elaborate. They are often made of ephemeral materials because these are cheap, and they favour the richness of luxuriant, baroque designs. Where the result must be 'just like life', extreme realism will be used. Horror, sex and sentimentality, which are rarely the themes of 'fine' art, crop up all the time. There is one common factor – energy, the vitality of creation that lurks in all of us, even if it is reduced to picking out a birthday card.

Complexity is our natural state, and simplicity only appeals to the sophisticated. Elaboration is the heritage of illiteracy and its long memories, and of long winter evenings of peasant life with nothing much to do – why knit plain when you can knit fancy? Many of the best postcards have a lot of elaborate detail, extra-exciting with their small size, or have complicated or punning themes, and some of them even change shape or color or subject.

Thin card is the ephemeral material of the postcard. The more expensive, arty ones were printed on good card, or on thick rag paper, but many had paper-lace edges, tissue-paper insets, silver-paper mirrors, real flowers and grasses, or real hair.

Even cards that were simple in design, like portraits of reigning beauties, were often given a frame for richness, a baroque-curved, gilded and embossed frame with a design elaborate enough to make up for the fact that it *was* printed and to give it a touch of class.

When realism would help an illusion, it was achieved by great skill in printing, sometimes with more embossing. The care with which some fantasy cards were drawn, photographed, montaged or faked would have pleased Bosch himself, and so would the horror and the sex, both in great variety – subtle or overt, delicate or violent.

Energy of invention, execution and design is clear on every postcard in this book. Certainly a lot of weak photographic views of sad villages and sepia cathedrals were also produced, but these are merely small flat representations of the workaday world and they have nothing to do with the postcards that are popular art; they are not art at all.

Fantasy, our main theme, is as inseparable from the popular arts as energy. Once the materials have been chosen and enough satisfying elaboration worked up on the sweet, sexy, violent or whatever theme, the odd quirks of the human brain take over, sometimes on a big scale, like the turning, glittering palace of a roundabout that puts its impaled racehorses at our service, or at the small scale of a toy, dressing a bear in human clothes and putting it in the arms of a baby.

The rise of the postcard stimulated such vagaries to an unprecedented degree. There can be no one reason for the cascade of 'fantesy and enchauntmentes' that began in the late nineties. Everything that had been bottled up for centuries seemed to go onto postcards. The small size helped: artists did not have to spend weeks on each design but could go quickly on from one idea to the next, invention breeding invention; failure was only a piece of paper wasted, instead of an expensive canvas. And artists inspired one another. How far they were also inspired by the fantasy-makers of the past we shall never know, for the most part their very names are forgotten, but I doubt if the designer(s?) of the heads on page 61 knew the Arcimboldo heads.

The postcard brought a rush of fantasy for the millions as well as for the millionaire – suddenly dreams of wealth, love, sex, travel, wit and beauty were set out on rectangles of colored card that could be instantly bought and sent. Four luxuries were offered at every street corner on the wire racks of the postcard stands. There was the luxury of a bit of art for oneself, and the luxury of communicating a serious desire or a passing thought with equal ease. Then there was the luxury of choice – this one? That's nicer. Ah, *that* one! Making a work of art involves countless decisions, taking your choice. Even without making a work of art, choice is creative; the aesthetic eye opens, however ineffectually, in the dullest head; criticism is born, even if only to measure things up against the dream world of the advertisements, and decisions are made. In a small way, everyone who chooses, creates. And lastly came the delicious luxury of going too far, sending naughty cards; they were so pretty, so open, who could take offence? Dirt went in envelopes, but postcards were only cheeky.

Twenty-five years seems to be the longest time that any major art can maintain the vitality of its prime, and this was so with the postcards, a scant twenty-five years. A lot of things came together to sweep postcards from their halting start to their amazing success in both quantity and design – great skills, cheap postage, small size, and also a certain freedom in the air, the lightness of a new century, a release from the repressions of a widespread 'respectability' that had nothing to do with respect and had gone on far too long. 'A penny saved is a penny gained' was suddenly less attractive than 'in for a penny, in for a pound'. Even if the pound was out of reach there was always a new postcard for the penny.

The scale of collecting paralleled the quantities of production; the postcard had exceeded its original purpose of messenger and become a desirable object to choose and send or receive and keep. A series of six might be sent off one a day to create suspense, as the cinema would soon create it with cliff-hanging serials. And there

were sets of three, six or twelve cards that were all meaningless on their own but fitted together to make a portrait of Napoleon or a long picture of a snake. The postcard album, carefully or haphazardly arranged according to temperament, was cherished in the parlour and might open with a card that read

POST CARD ALBUM
This is my album, but learn as you look,
All are expected to add to my book:
You are welcome to 'quiz' it – the penalty is,
You send me a Post Card for others to 'quiz'.

And friends obeyed.

Today we are collecting again, with nostalgia as an added luxury. We choose from postcard racks that now hold the survivors of thousands of holocausts and attic clearances made when the albums and shoeboxes were old junk, not yet seen as popular art or even as microcosms of the Edwardian world. Some cards may have gone for ever, but there are constant rediscoveries (and every modern collector knows that as soon as a set of six is completed it will turn out that there were twelve after all).

Postcards are still made, of course, but the overwhelming majority are dull-bright colored photographs that have only the fantasy of the ever-turquoise sky. They are aesthetically dull, bought as a duty in holiday places; the buyers choose reluctantly, and send them at the last minute – *must* get those cards off or we'll be home before they get there. Certainly some of the shock tactics and puns of the old card have gone into the modern millions of greeting cards and cards for all occasions to save writing, but these are either merely insulting or most sickeningly sweet and, in their two tasteless styles, all look alike. The old élan of fantasy has gone from the postcard and its successors, but it will come back somewhere else, just as the second Lord Berners' 'fantesy' was echoed by the ninth Lord Berners when he dyed his white doves pink and blue and green, and tied bamboo whistles to their tails so that the wind made music when they flew.

Barbara Jones, like the author, is an artist and a keen postcard collector. She has painted numerous murals for exhibitions and public buildings, and has designed all sorts of things from a coffin handle to a Lord Mayor of London's Show. Her published books include *The Unsophisticated Arts, Follies and Grottoes,* and (with Bill Havell) *The Popular Arts of the Great War.*

It is not far-fetched to think that a shoeboxful of old picture postcards could comprise an informal social history of their era. Though millions of these ephemeral bits of the past have fallen victim to periodic spring cleanings and World Wars, enough survive to give us insights into those transitory moments of life so immediately captured in pictures. But these very insights are suspect, for they come to us through the complex layers of historical, aesthetic and psychological sophistication which time has determined to be our modern viewpoint. Though we can approach the past from a distance, we can never get close enough to breathe its air or touch its life; we must interpret its meaning from clues and read between the lines. Our interpretation of past reality, colored by imagination, becomes a creative act. This being so it seems interesting to include in the shoebox encyclopedia, along with cards depicting the everyday life of the 'real' world, a precious group which documents the world of the imagination itself, those postcards consciously intended to relax the mind from everyday cares, provide a good laugh, a bit of titillation, or a brief escape into reverie. By encountering intentional fantasies from the past we can experience this reverie today and take similar delight in identifying with an imaginary world which never was and never can be.

It is a world where tiny people sail in seashell boats, whole families fly through the air on a sausage and snowmen drive automobiles; where ladies emerge as butterflies, sleep with lobsters, and get imprisoned in soap bubbles; where mountains have faces, pigs wear clothes and babies sprout from cabbages. Like life in that other world outside, it ranges from the gentle to the witty, the satiric, the audacious, and the bizarre; from the innocent to the erotic; and from the sane to the utterly mad.

These small miracles are usually drawings, paintings, or photographs created especially for reproduction as postcards. Very often they were produced by the new technique of photomontage, using the persuasively 'real' images from several photos cut and recomposed to give the illusion of reality. This effect of altered reality is sometimes heightened further when elements of painting are applied to the montage and areas are retouched to add, remove or accent detail. Early postcard artists were responsible for developing this valuable technique into what is now considered a valid art form; it is the major technique of the fantasy postcard.

But there is another kind of fantasy hidden in the shoebox, waiting to be discovered among the hundreds of views of everyday life: the fantasy-in-spite-of-itself. These unintentional fantasies are found in works originally conceived as serious straightforward documents. They are not ready-made fantasies, but rather the raw material from which our reverie creates them, and in this respect they have less to do with the past than with our own present.

Close inspection often reveals oddities, inconsistencies and ambiguities which prompt feelings and questions at odds with the original intention of the picture. If we relax our everyday logic, reverie spontaneously suggests associations which lead us to the edge of fantasy. We begin to see a different reality in a world we

thought was commonplace. An old sculptor seated amongst his carvings appears to be one of them. This straightforward document of a man and his work makes us begin to think in new ways. A man is stretched out on a slab like a corpse. He is not dead, merely taking the cure at a spa – getting well, in fact – this irony, based on the ambiguity of the image, is our own, the result of a new kind of seeing. By chance a wave is retouched to look more like a cloud. An accident in color registration makes a famous beauty cross-eyed. Instant fantasy! The end of an otherwise ordinary street seems to vanish. Who lives at the end of the street, if the end exists? Can we take a mental walk there, and if we arrive, will we vanish too? Could nowhere lead us to infinity? We are free to see and develop the images in any way we choose.

Certain publishers specialized in scenes photographed in studio settings resembling both the local photographic parlor with its stock drops and props and the contemporary theatre, where such artificiality was intended to be accepted as reality. Today we accept the illusion as an illusion, welcoming the obvious staginess and delighting in the visual irony caused by the contrast of illusion and reality. From this point of view, the best of these publishers is A. Bergeret & Company of Nancy, France, which dealt in typically fanciful French subjects: Pierrot, Paul and Virginie, fairy tales, the language of the flowers, food, games, and kisses, mixing a charm and delicacy of intention with an attempt at bourgeois respectability which fails, endearingly, in execution. Sets were usually flat painted drops and two-dimensional cut-outs resembling in style the contemporary films of magician Georges Meliès, whose extraordinary cinema vision in turn resembles fantasy postcards set to motion. Bergeret's props tended to be versatile: the Grecian drapery of one shot might double as a table cloth in another. The models doubled too: one recognizes the same urchins and shopgirls in a wide variety of situations, and the same old man impersonating Father Time. The consciously graceful poses and arrangements *à la manière française* occasionally evoke the style and charm of the French music hall, with lots of plump, spangled girls decoratively standing around or flourishing in first position.

Since each separate color on early postcards was chosen by the printer's not always unfailing eye, there is much latitude for accident or eccentricity, and hand-tinting by stencil process which resembles watercolors was often delicate and subtle, but also produced many remarkable accidents. The whole mood and intention of an idyllic landscape can be changed if the sky is too dark, too grey; the psychology of a face altered – or revealed – by its fortuitous ruddiness or pallor.

The demand for variety or simple thrift tempted publishers to reuse printing plates, replacing certain elements in the design with others. Thus, the Man-in-the-Moon is metamorphosized into a jack-o-lantern. Economy convinced one printer to retouch an entire scene of the boardwalk at Atlantic City, radically transforming day into night, but leaving all the people exactly in place. When we see the two versions together, 'documentary' reality is revealed as unintentional fantasy.

Finding the missing cards to complete a series can become a frustrating task, but it can be turned to advantage. To a collector of fantasies, just one card from a series tantalizes, stimulating speculation as to what the other cards might reveal. The unknown liberates us to create our own logical reality from fragments, like an archaeologist.

Once pictures are juxtaposed, for whatever practical or fanciful reason, a tension

is set up, a relationship implied which can then be interpreted. Meanings are suggested which might never have been intended, spontaneous accidental associations, subtle connections which generate feelings if not words. One card of a reclining nude is placed beside another of a speeding motorcyclist. Depending on the order of the images, the motorcyclist is either rushing toward his goal or rapidly taking his leave. Add a third card of an empty bed and this particular plot thickens. In another combination, placing the reclining nude over the empty bed, she appears to levitate; the motorcyclist over the bed foreshadows disaster. Several images can be shuffled, laid out and 'read' like the tarot, each new juxtaposition affecting the previous one. The incongruity creates a new reality which we can believe if we chose. We can indulge the perverse pleasure of conscious misinterpretation, supplying a new logic, a fantasy 'truth' of our own creation.

The Surrealists learned that one can dream while awake as well as while asleep. By 1924, when their movement came into being, its members had literally grown up with the fantasy postcard, and recognized the mysterious dreamlike plausibility and unconscious symbolism of many of its images, as poet Paul Eluard's fine collection testified. One art feeds another: the naïve and popular art of the postcard helped inspire the Surrealists to evolve theories which affected mid-twentieth-century man's vision of life, and without them we would be unable to respond to these postcards as we do today.

Obviously, uncovering fantasies means unlocking our imagination. To do this we must be free to learn how to play, to fool ourselves, and yet to trust our instincts and whims, reveries and spontaneous associations. We must learn to recognize and welcome the accidental, the ambiguous and the illogical. Besides enjoying ourselves in the process, we will realize that there is no such thing as face value, that the surface of the ordinary masks hidden resources, the beginnings of poetry waiting to be discovered.

The pictures which follow are presented without text in the belief that poetry explains itself perfectly well without outside interference. Any additional comments have been reserved for the notes at the end.

William Ouellette
New York City, 1975

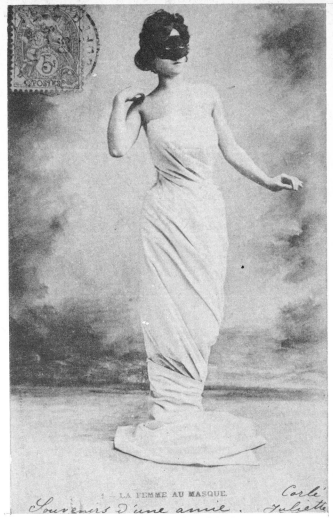

LA FEMME AU MASQUE.

Souvenirs d'une amie.

Corli
Juliette

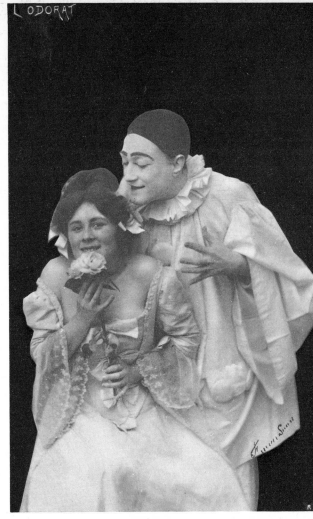

L'ODORAT

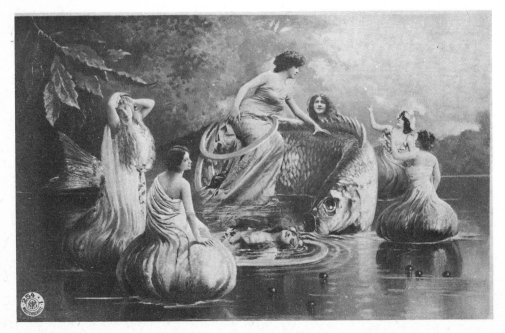

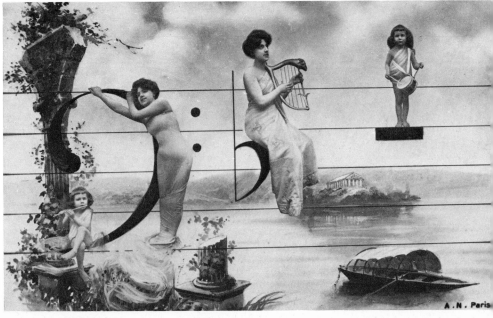

A.N. Paris

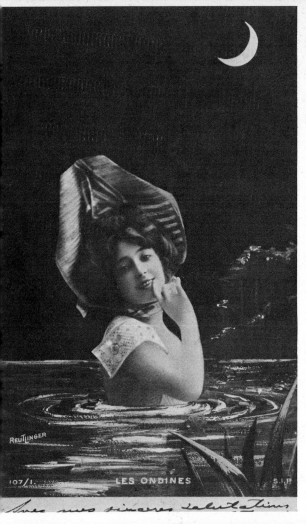

LES ONDINES

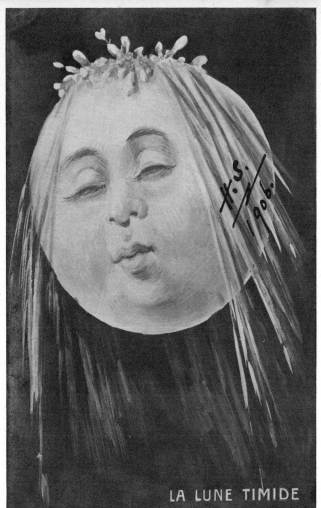

LA LUNE TIMIDE

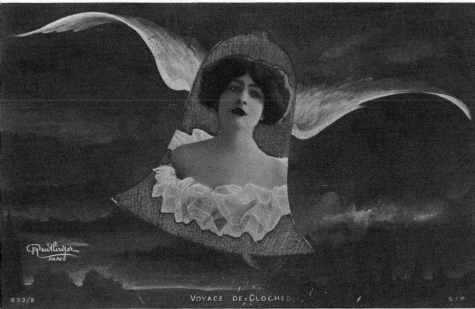

VOYAGE DE CLOCHES

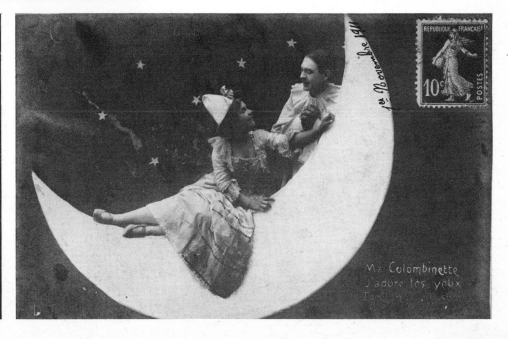

18

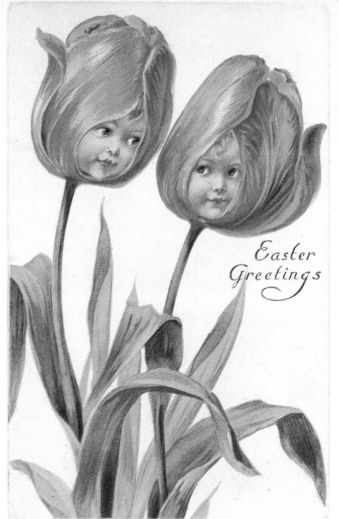

Easter
Greetings

SER 604

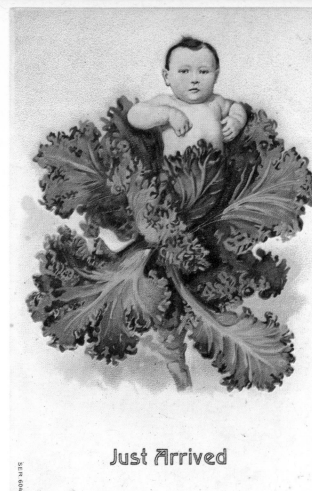

Just Arrived

Souvenir

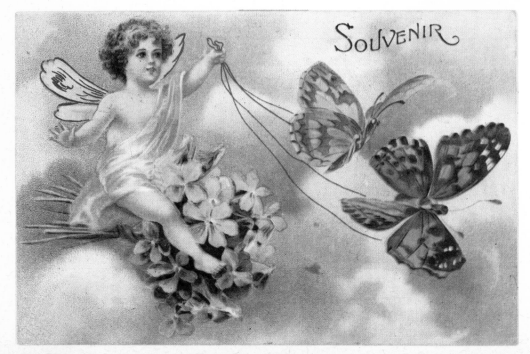

"Ping Pong" in Fairyland II.

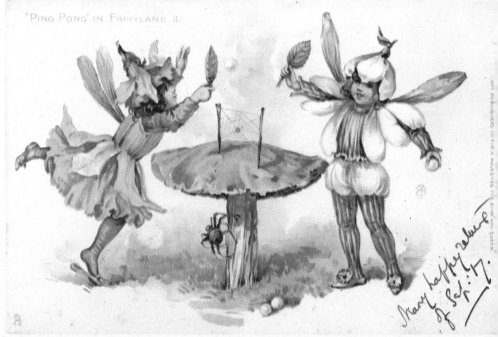

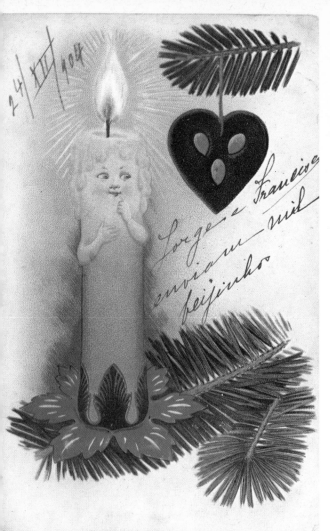

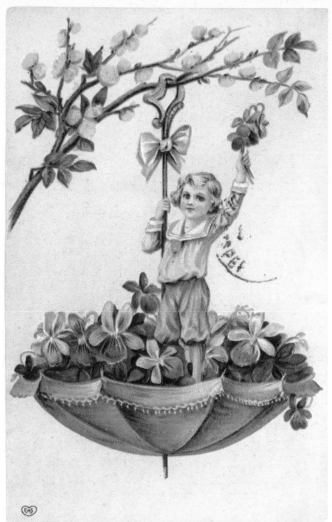

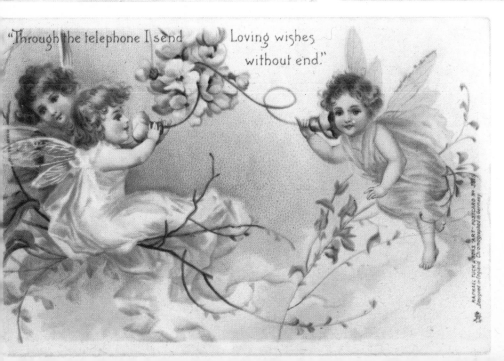

"Through the telephone I send Loving wishes
 without end."

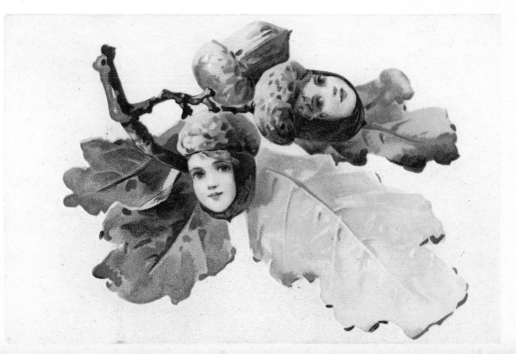

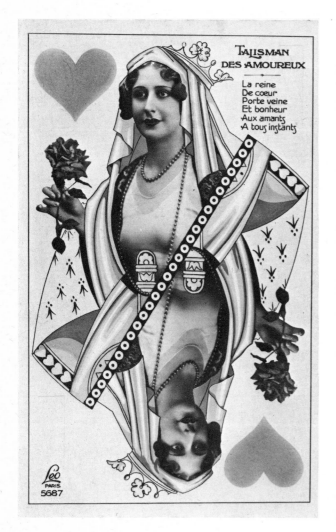

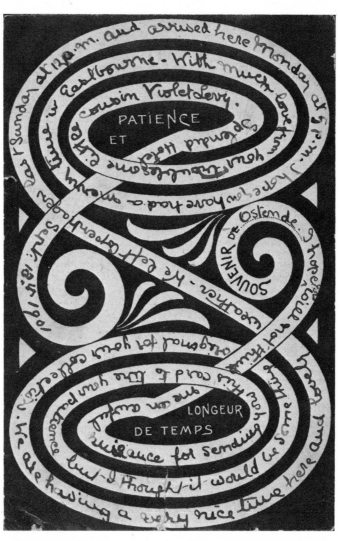

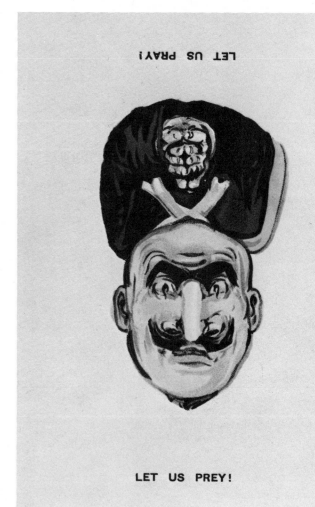

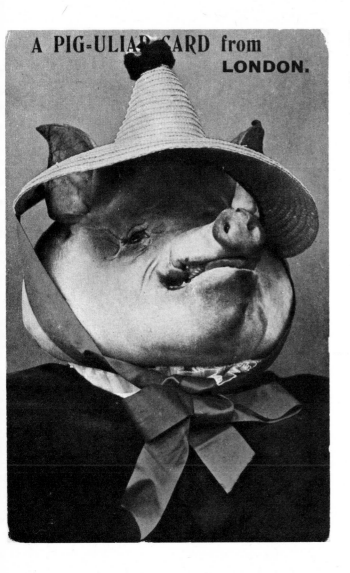

A PIG-ULIAR CARD from LONDON.

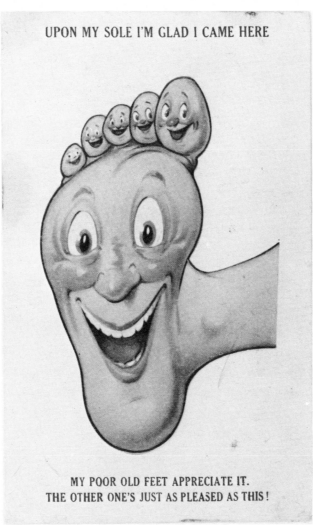

UPON MY SOLE I'M GLAD I CAME HERE

MY POOR OLD FEET APPRECIATE IT.
THE OTHER ONE'S JUST AS PLEASED AS THIS!

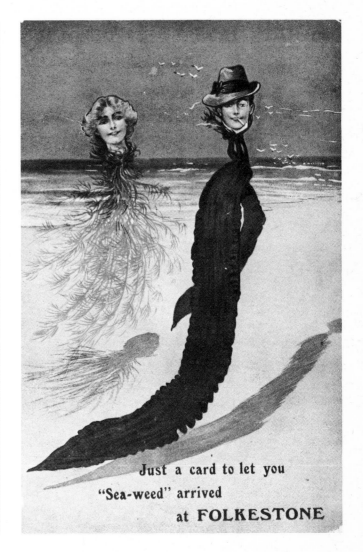

Just a card to let you
"Sea-weed" arrived
at FOLKESTONE

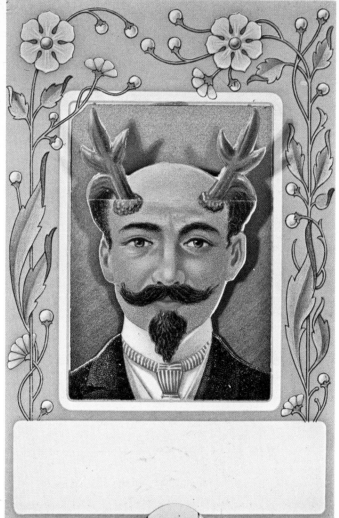
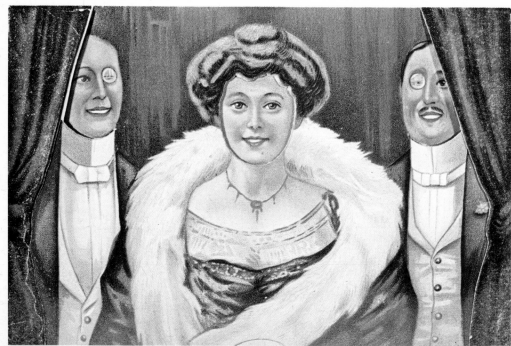
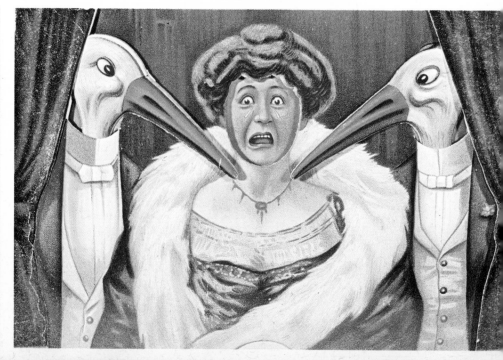

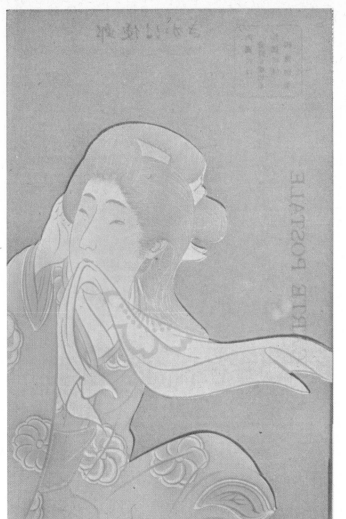

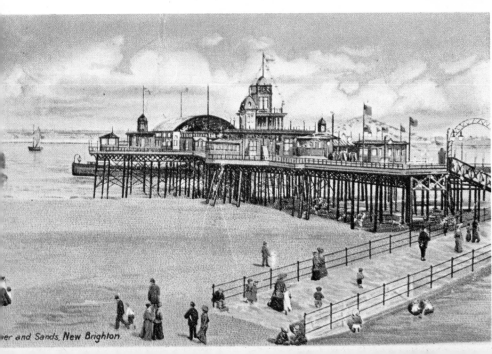

Pier and Sands, New Brighton.

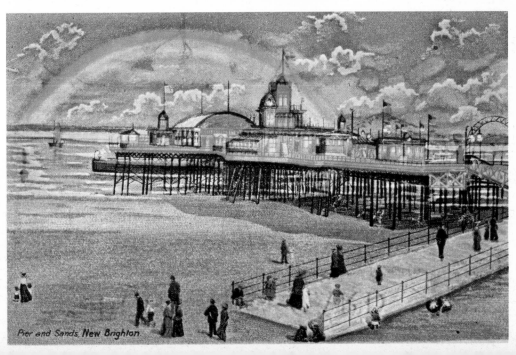

Pier and Sands, New Brighton.

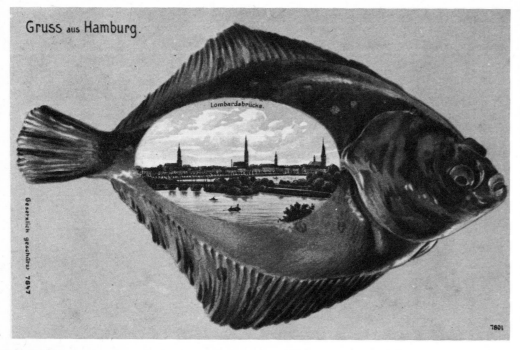

Gruss aus Hamburg.

Lombardsbrücke.

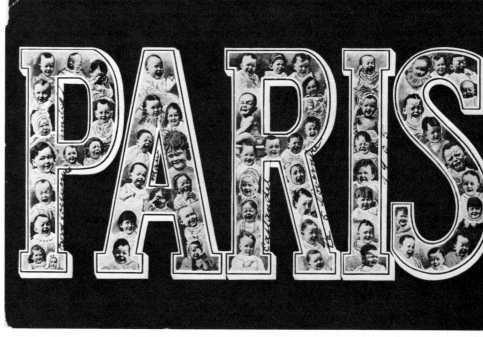

PARIS

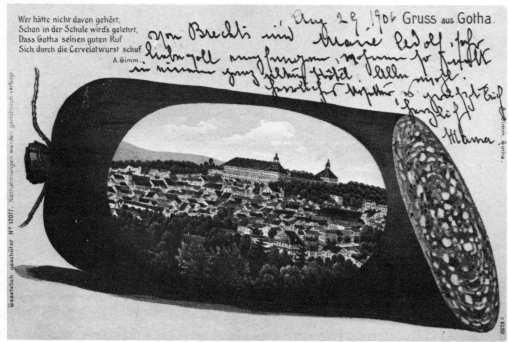

Wer hätte nicht davon gehört,
Schon in der Schule wird's gelehrt,
Dass Gotha seinen guten Ruf
Sich durch die Cervelatwurst schuf.
A. Gimm.

Gruss aus Gotha.

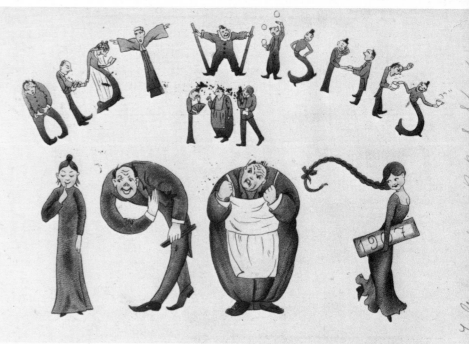

BEST WISHES 1907

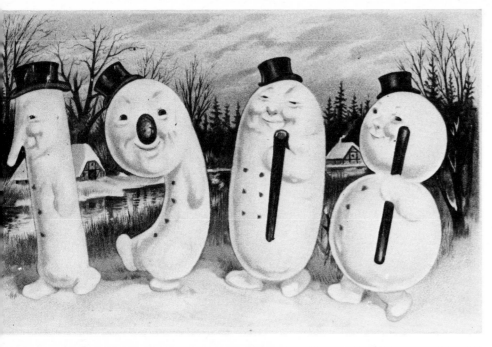

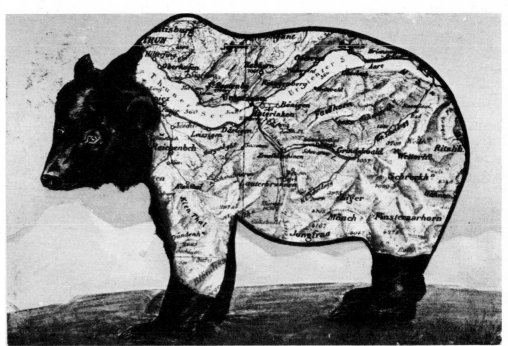

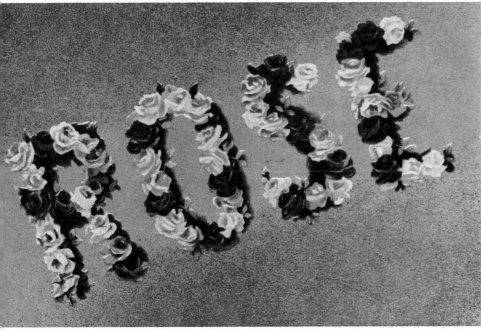

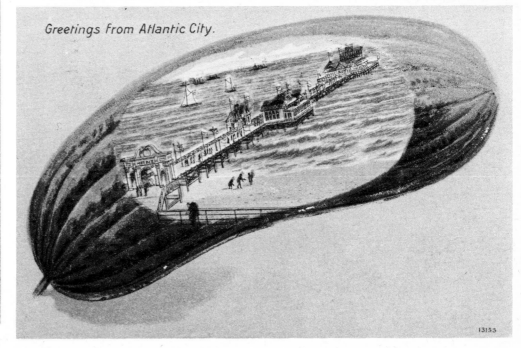

Greetings from Atlantic City.

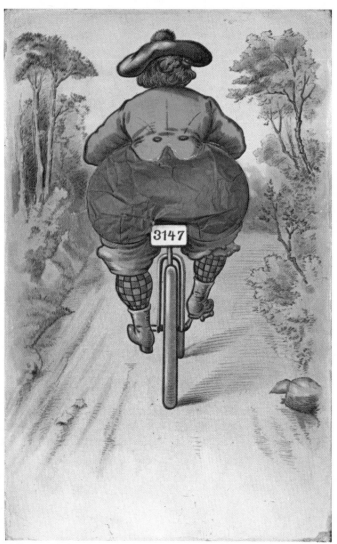

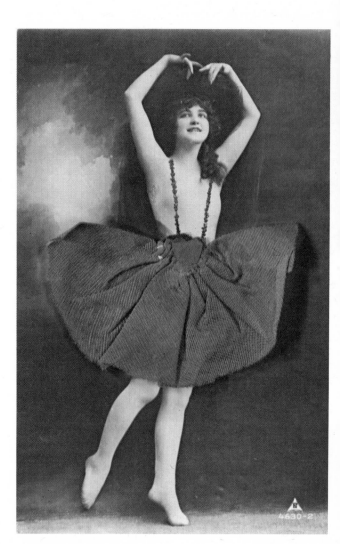

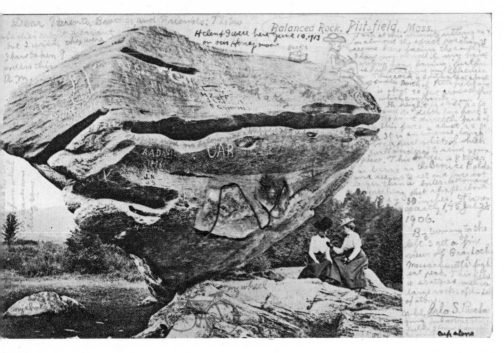

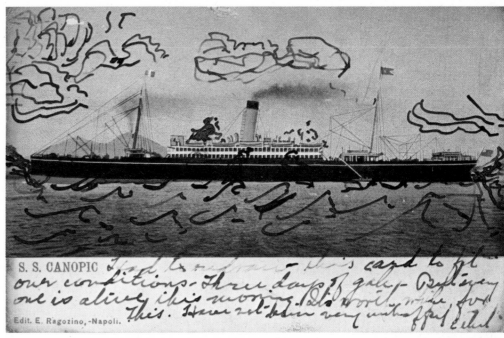

S. S. CANOPIC

Edit. E. Ragozino, -Napoli.

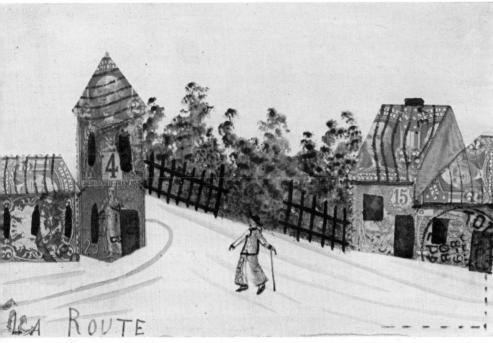

LA ROUTE

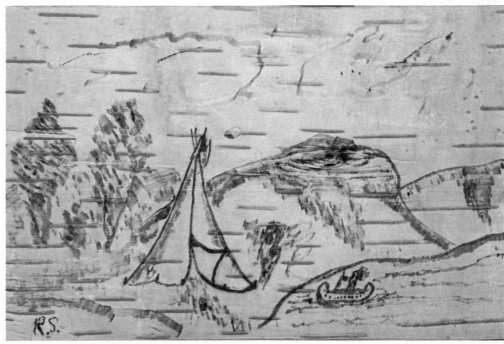

R.S.

28

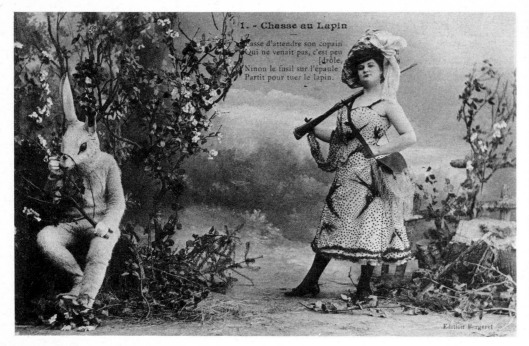

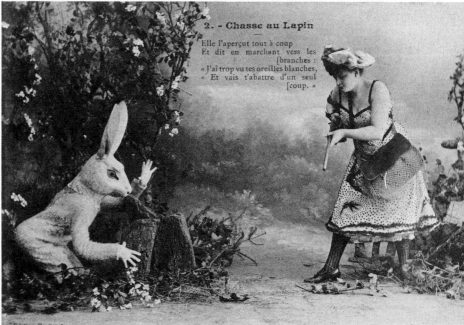

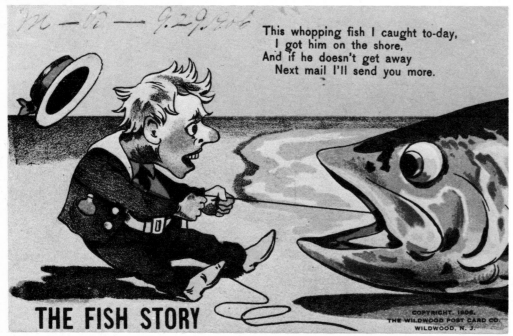

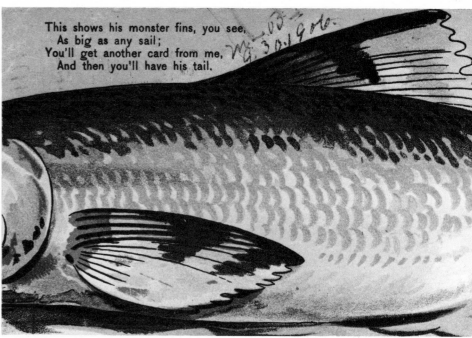

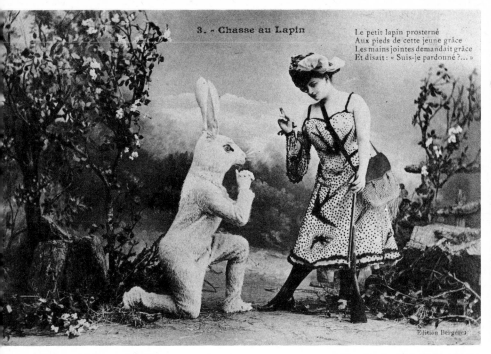

3. - Chasse au Lapin

Le petit lapin prosterné
Aux pieds de cette jeune grâce
Les mains jointes demandait grâce
Et disait : « Suis-je pardonné ?... »

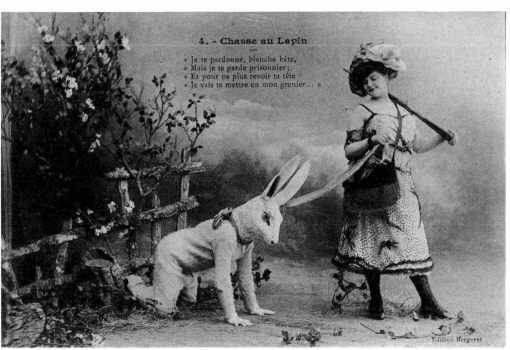

4. - Chasse au Lapin

« Je te pardonne, blanche bête,
« Mais je te garde prisonnier ;
« Et pour ne plus revoir ta tête
« Je vais te mettre en mon grenier... »

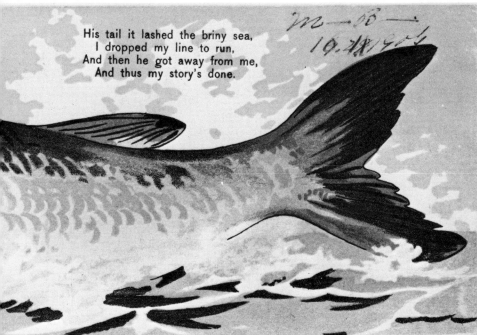

His tail it lashed the briny sea,
I dropped my line to run,
And then he got away from me,
And thus my story's done.

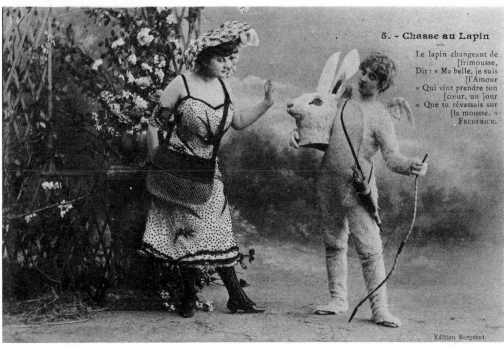

5. - Chasse au Lapin

Le lapin changeant de
[frimousse,
Dit : « Ma belle, je suis
[l'Amour
« Qui vint prendre ton
[cœur, un jour
« Que tu rêvassais sur
[la mousse. »
FRÉDÉRICK.

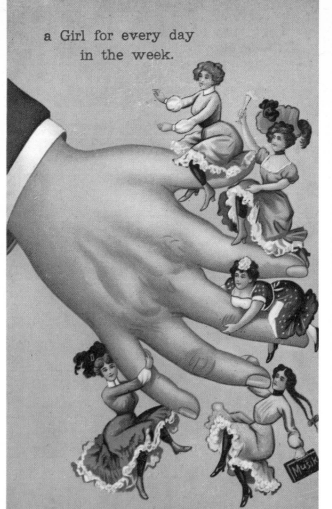

a Girl for every day
in the week.

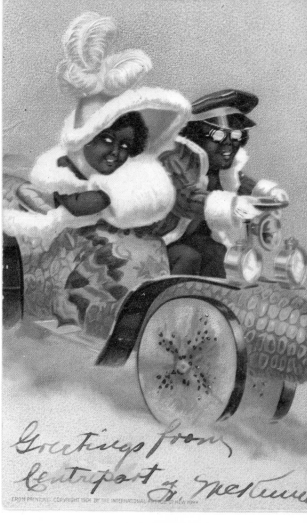

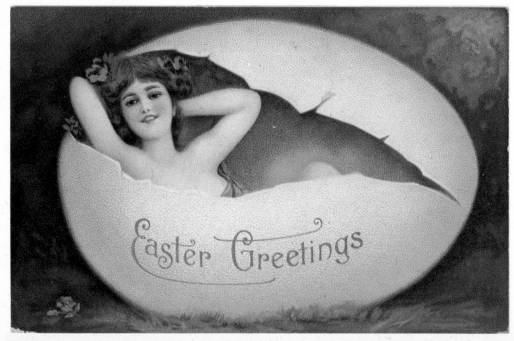

Easter Greetings

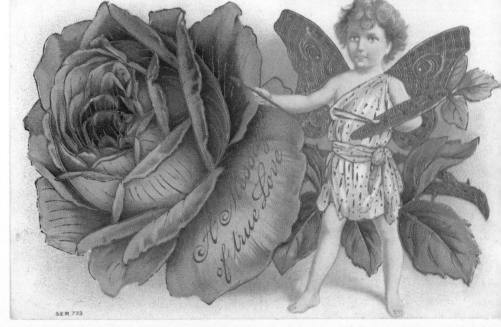

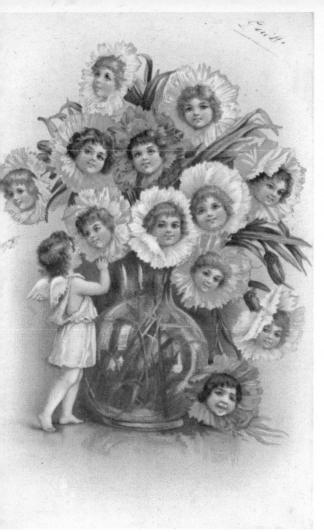

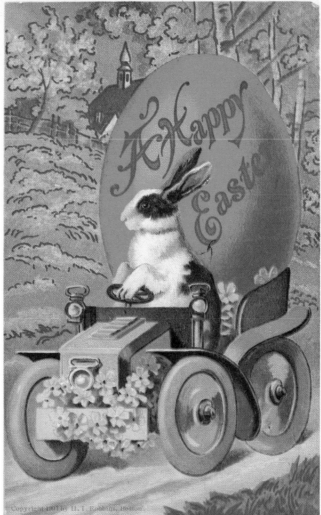

A Happy Easter

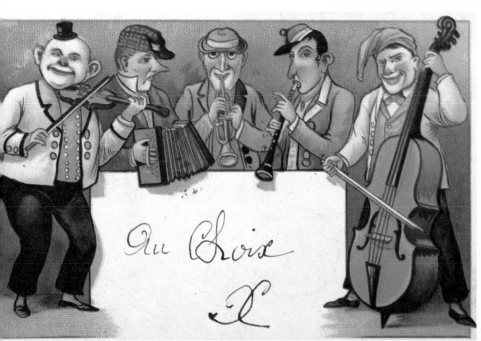

Au Choix

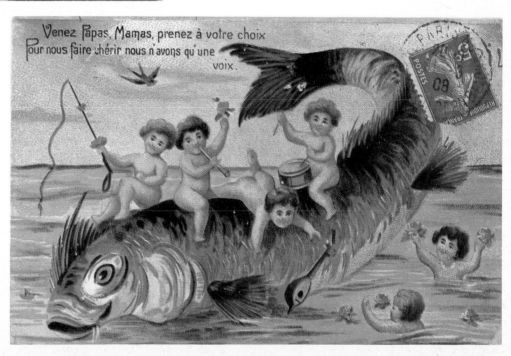

Venez Papas, Mamas, prenez à votre choix
Pour nous faire chérir nous n'avons qu'une voix.

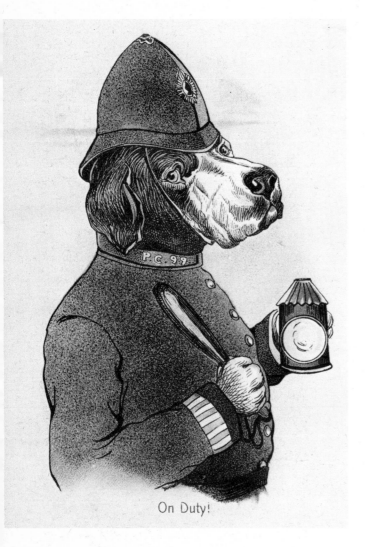

On Duty!

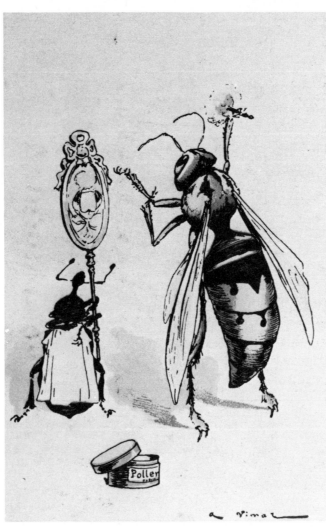

Poller

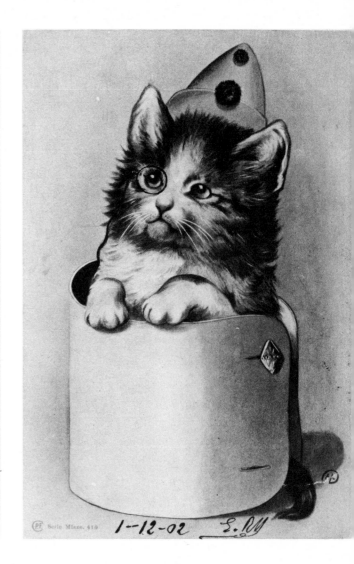

1-12-02

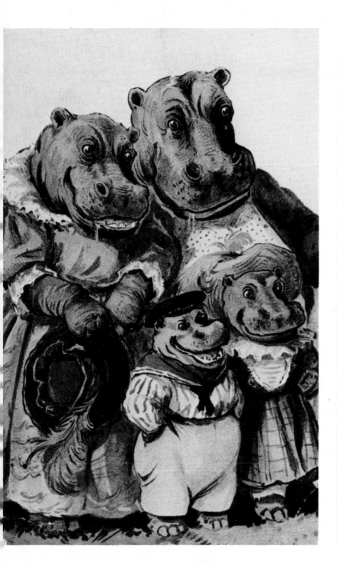

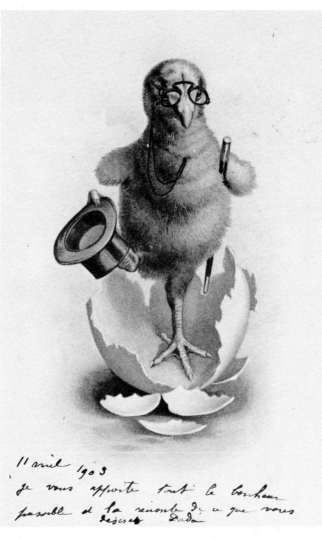

11 avril 1903
je vous apporte tout le bonheur
possible et la réussite de ce que vous
désirez. Dada

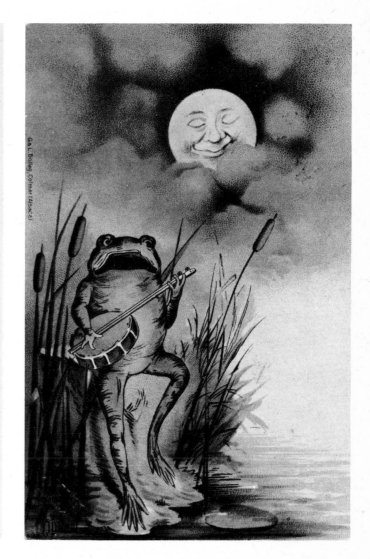

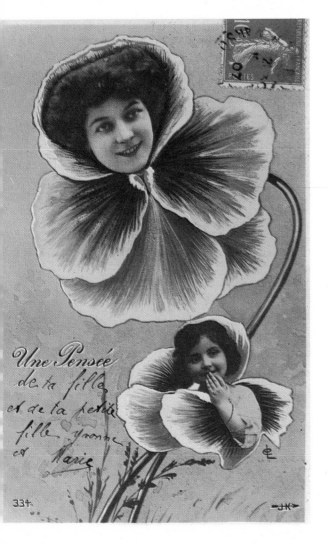

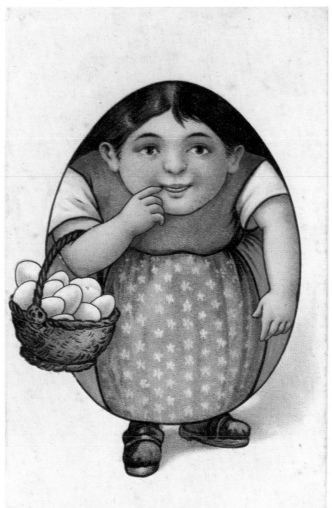

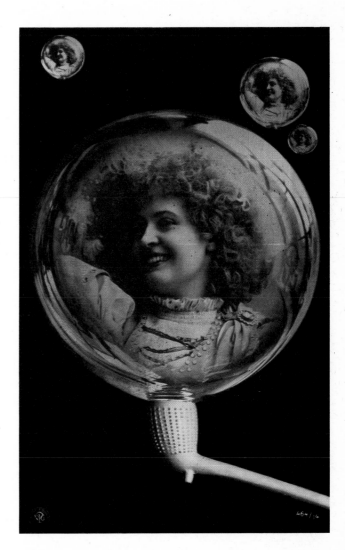

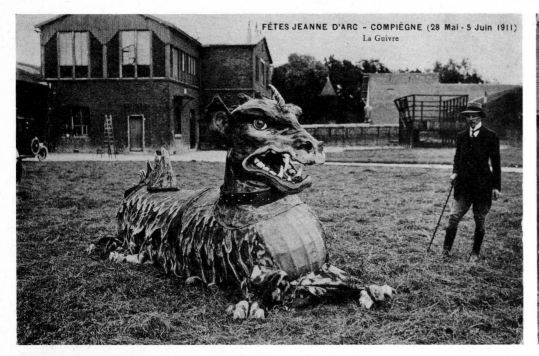

FÊTES JEANNE D'ARC - COMPIÈGNE (28 Mai - 5 Juin 1911)
La Guivre

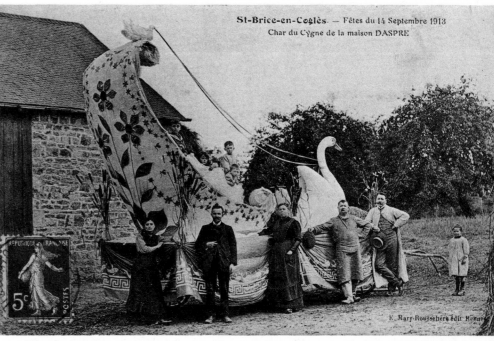

St-Brice-en-Coglès. — Fêtes du 14 Septembre 1913
Char du Cygne de la maison DASPRE

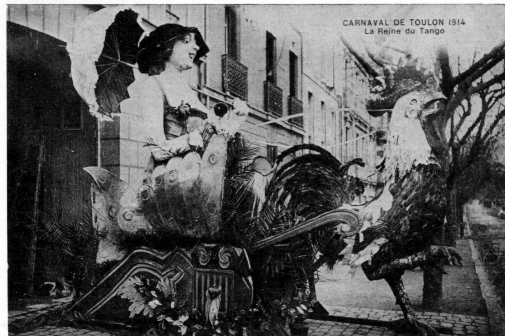

CARNAVAL DE TOULON 1914
La Reine du Tango

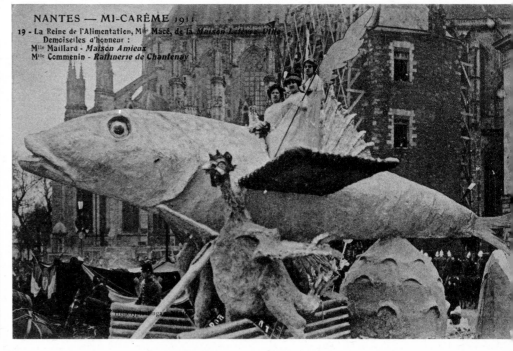

NANTES — MI-CARÊME 1911
19 - La Reine de l'Alimentation, M. Macé, de la Maison Lefeuvre Ville
Demoiselles d'honneur :
M. Maillard - Maison Amieux
M. Commenin - Raffinerie de Chantenay

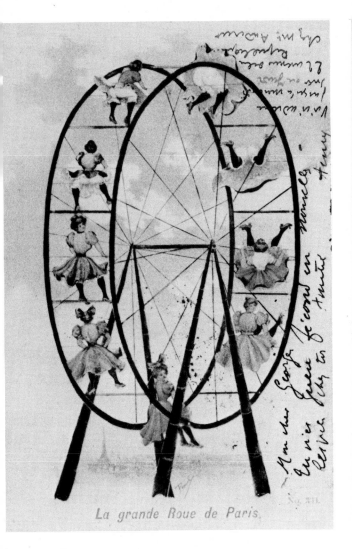

La grande Roue de Paris.

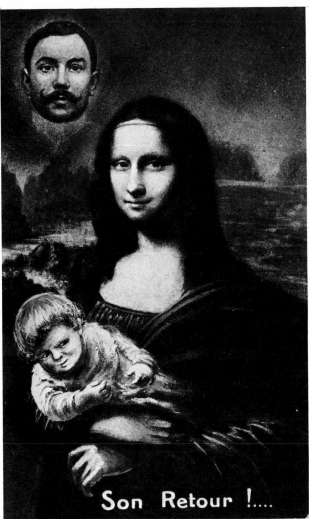

Son Retour !....

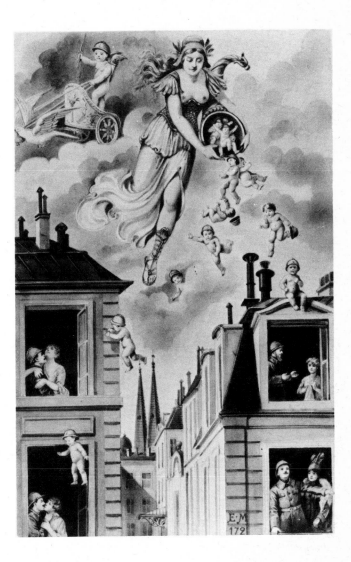

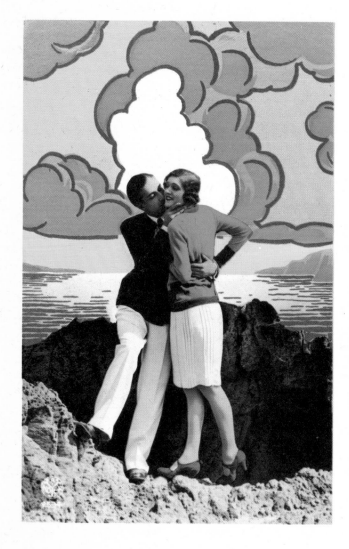 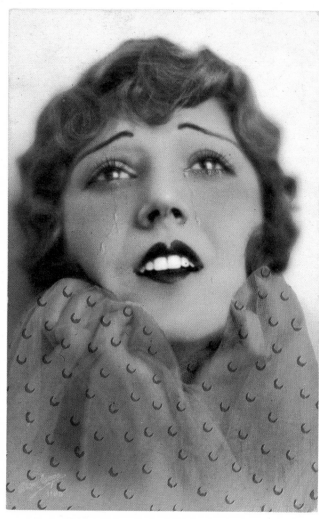 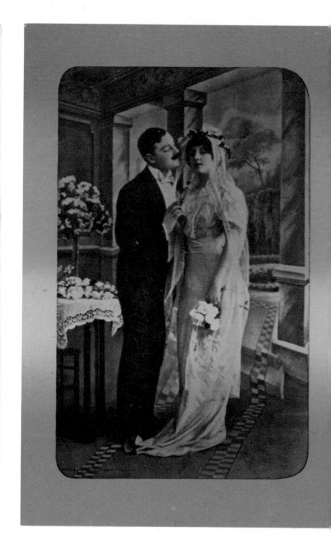

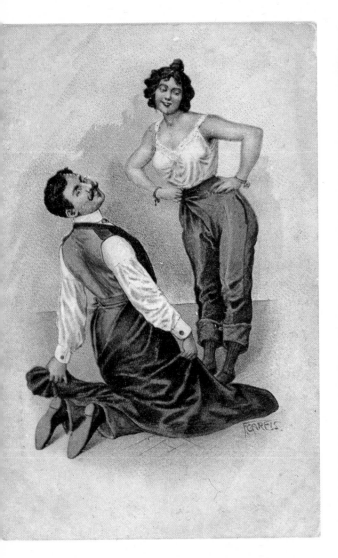

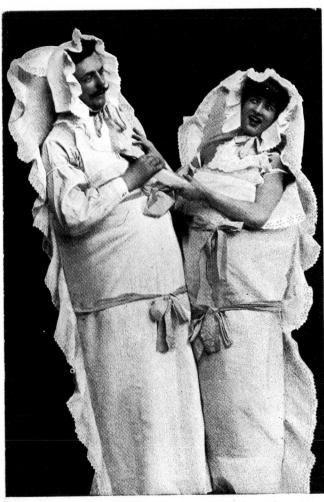

I'll cry for mother!

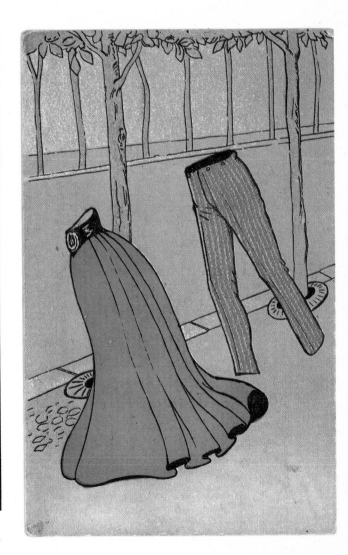

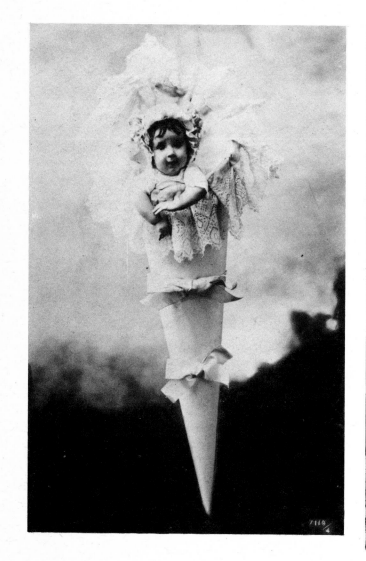

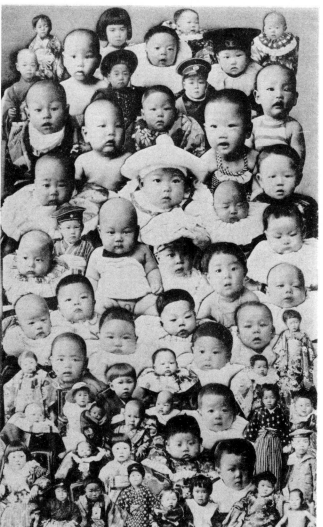

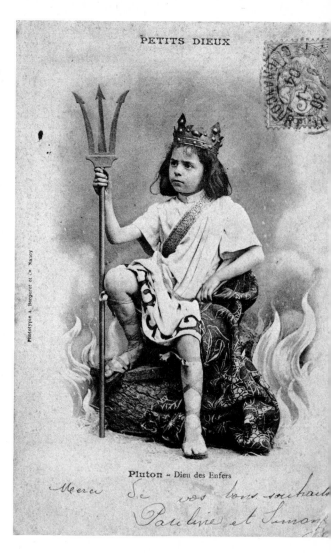

PETITS DIEUX

Pluton – Dieu des Enfers

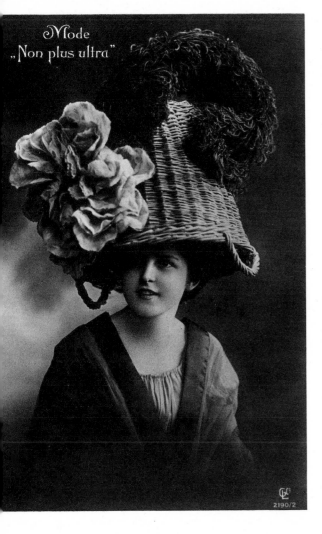

Mode
„Non plus ultra"

2190/2

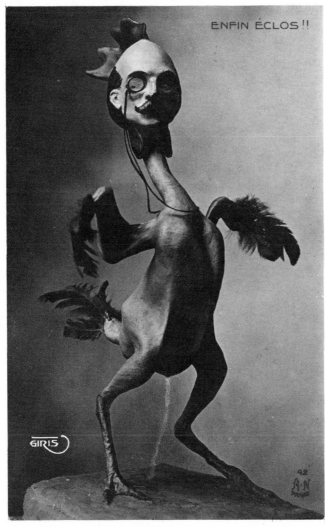

ENFIN ÉCLOS!!

GIRIS

42

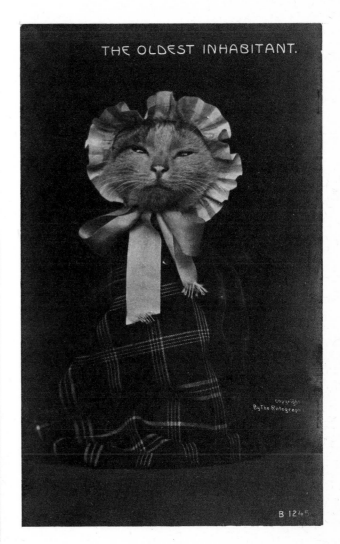

THE OLDEST INHABITANT.

Copyright
By The Rotograph

B 1245

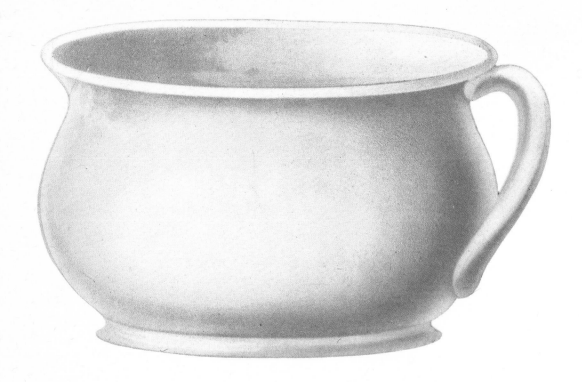

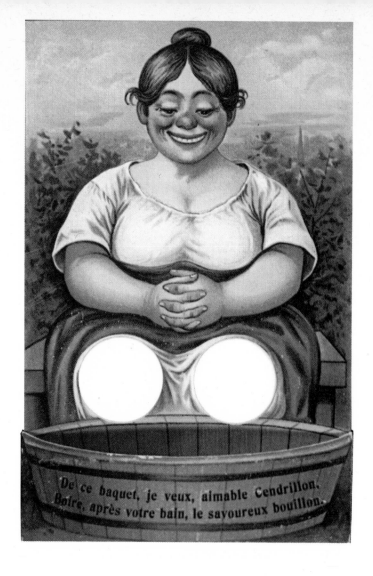

De ce baquet, je veux, aimable Cendrillon,
Boire, après votre bain, le savoureux bouillon.

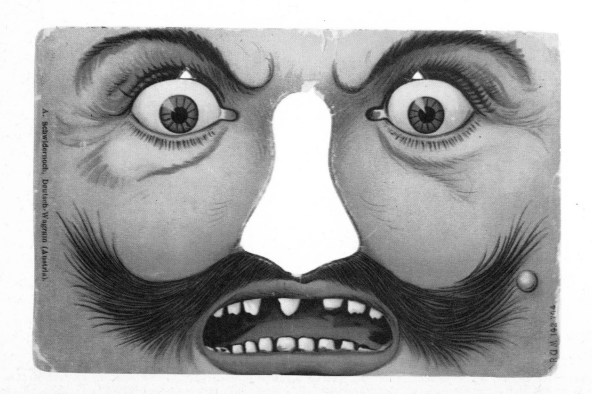

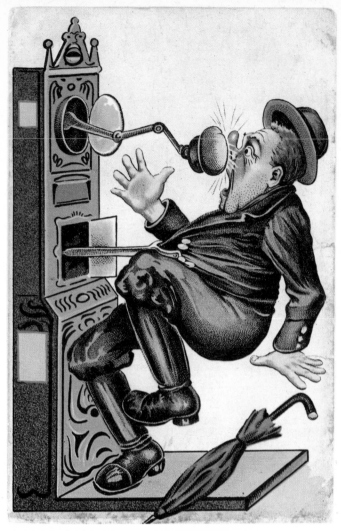

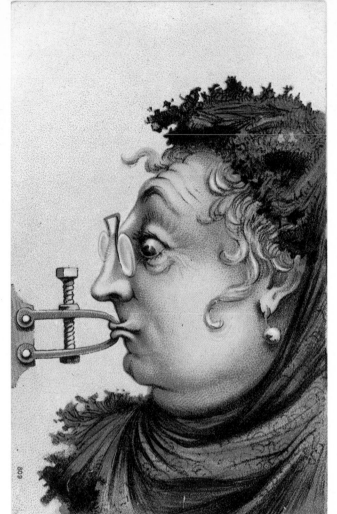

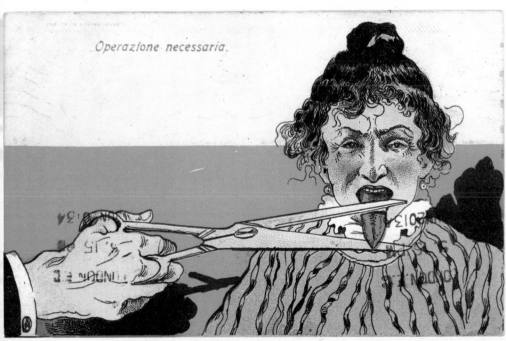

Operazione necessaria.

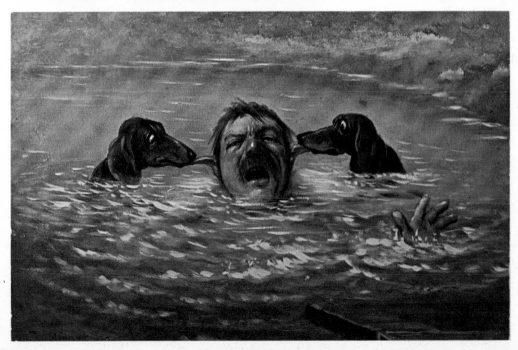

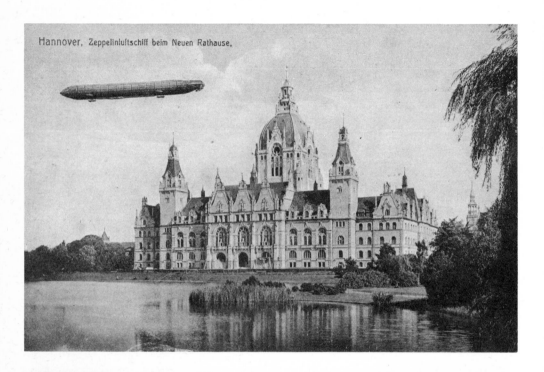

Hannover, Zeppelinluftschiff beim Neuen Rathause.

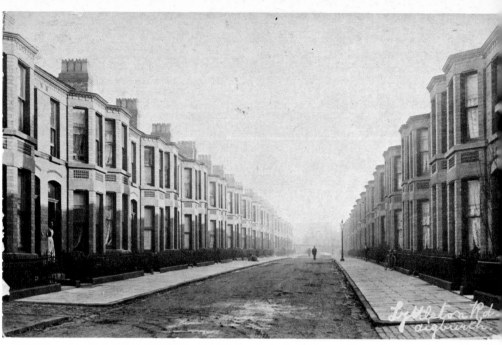

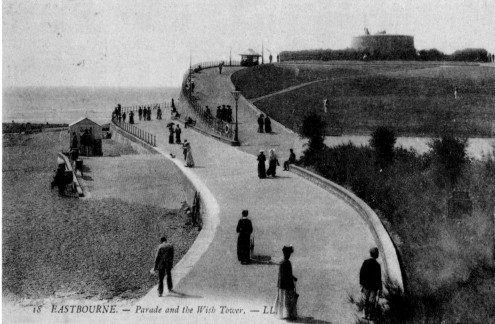

18 EASTBOURNE. — Parade and the Wish Tower. — LL.

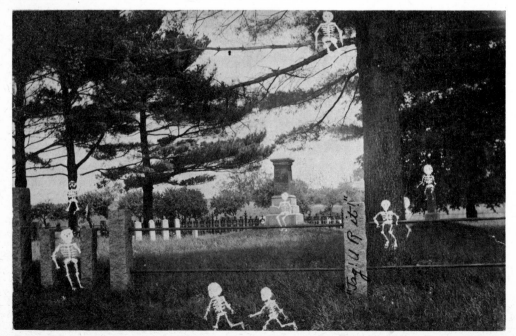

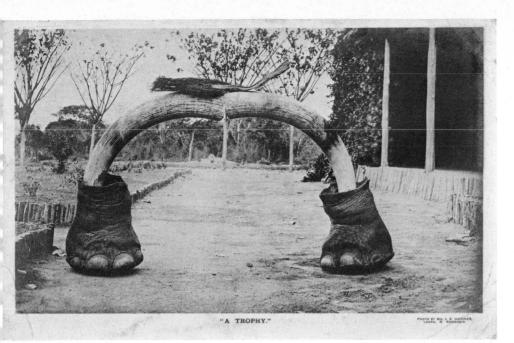

"A TROPHY."

PHOTO BY MR. J. E. HUGHES,
LUSAA, N. RHODESIA.

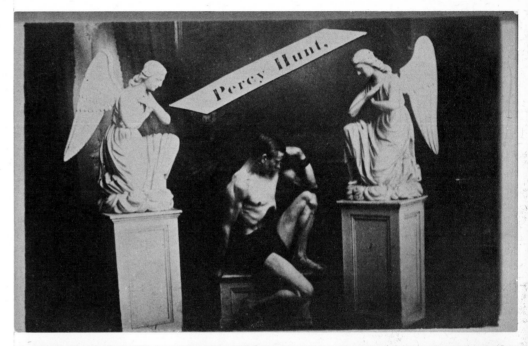

Percy Hunt.

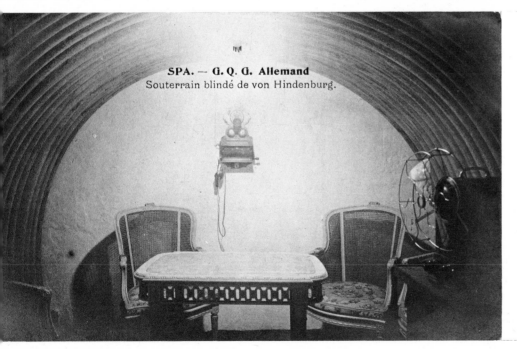

SPA. — G. Q. G. Allemand
Souterrain blindé de von Hindenburg.

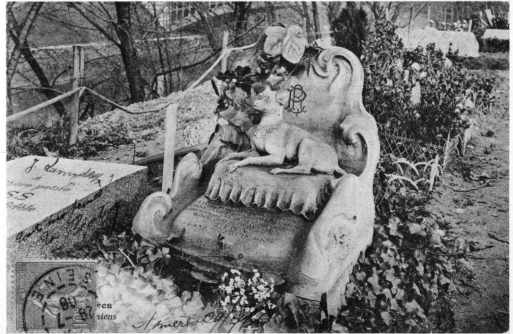

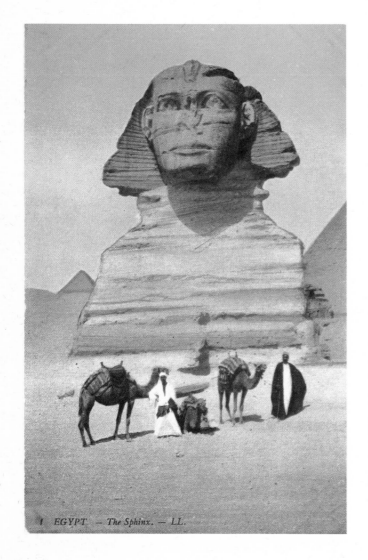

1 EGYPT — The Sphinx. — LL.

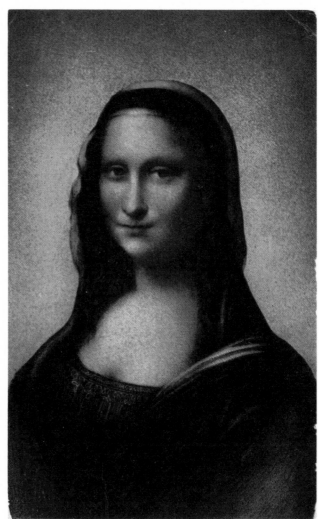

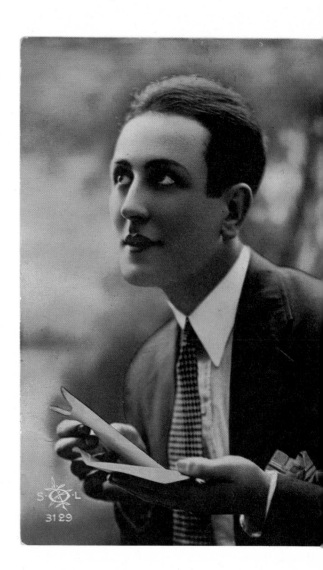

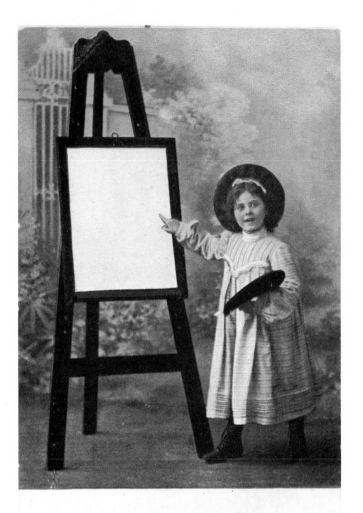
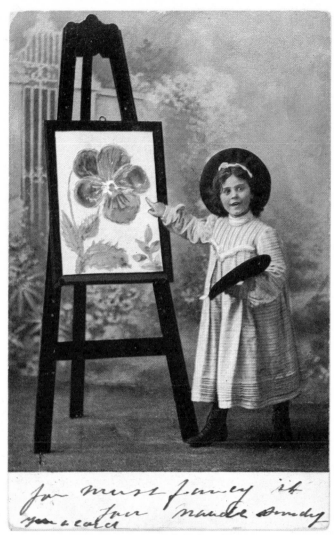

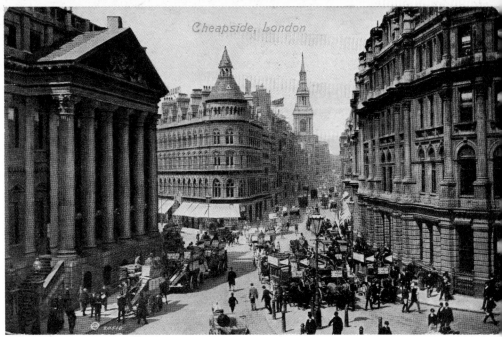

Cheapside, London

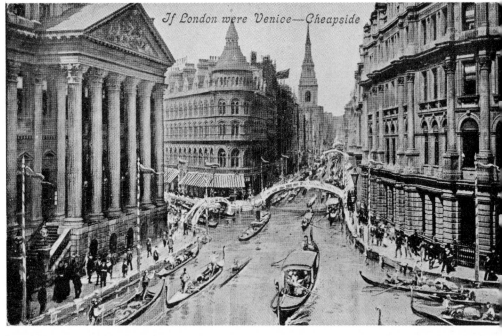

If London were Venice—Cheapside

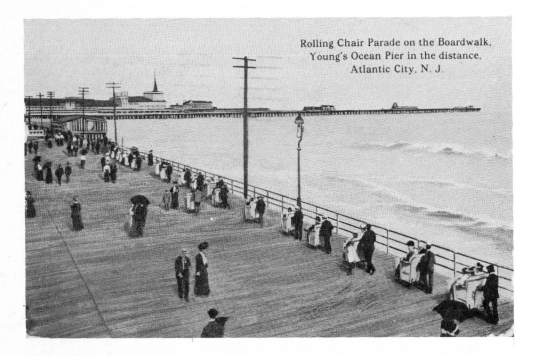

Rolling Chair Parade on the Boardwalk,
Young's Ocean Pier in the distance.
Atlantic City, N. J.

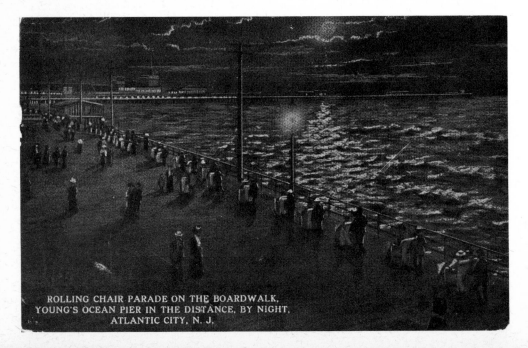

ROLLING CHAIR PARADE ON THE BOARDWALK,
YOUNG'S OCEAN PIER IN THE DISTANCE, BY NIGHT,
ATLANTIC CITY, N. J.

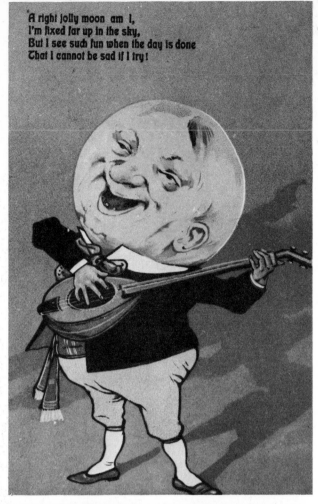

A right jolly moon am I,
I'm fixed far up in the sky,
But I see such fun when the day is done
That I cannot be sad if I try!

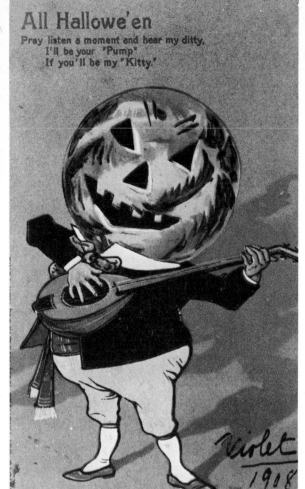

All Hallowe'en

Pray listen a moment and hear my ditty,
I'll be your "Pump"
If you'll be my "Kitty."

violet
1908

Atlantic City, N. J.

Breakers at Asbury Park, N. J.

50

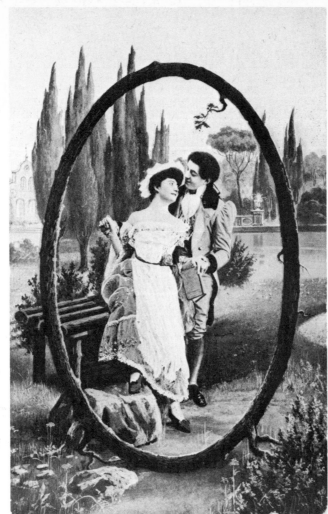

THIS IS HOW WATERMELONS GROW IN CALIFORNIA.

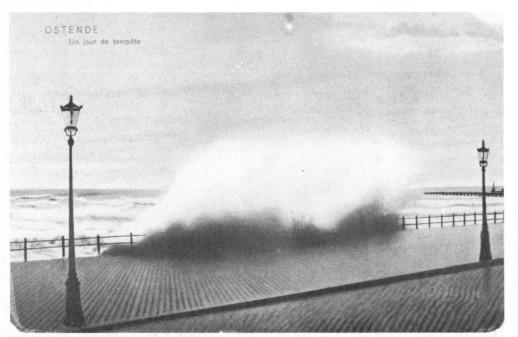

OSTENDE
Un jour de tempête

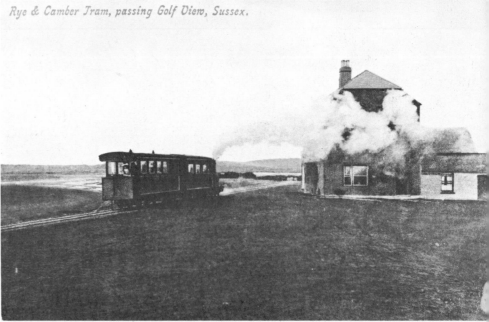

Rye & Camber Tram, passing Golf View, Sussex.

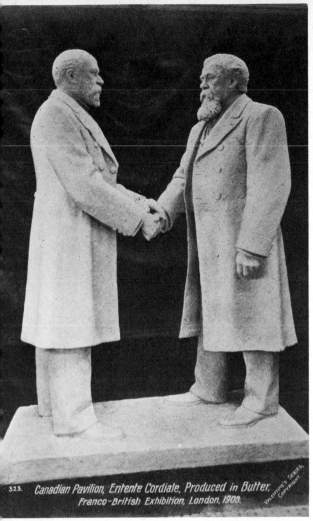

323. Canadian Pavilion, Entente Cordiale, Produced in Butter,
Franco-British Exhibition, London, 1908.

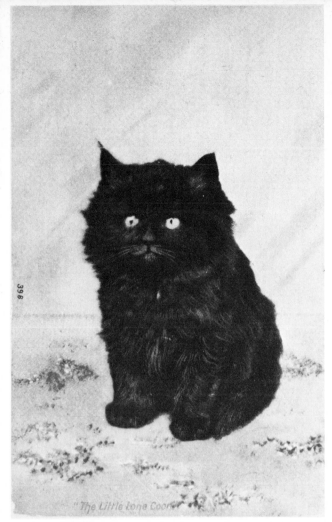

"The Little Lone Coon"

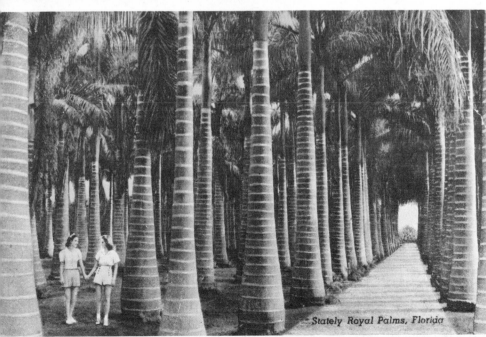

Stately Royal Palms, Florida

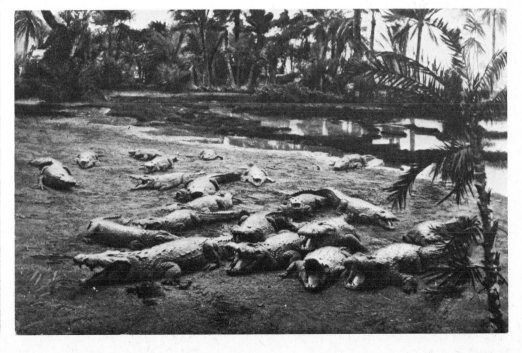

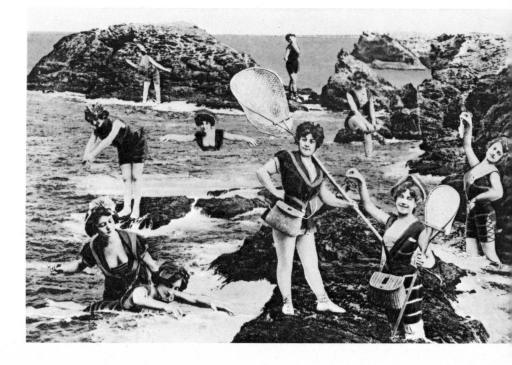

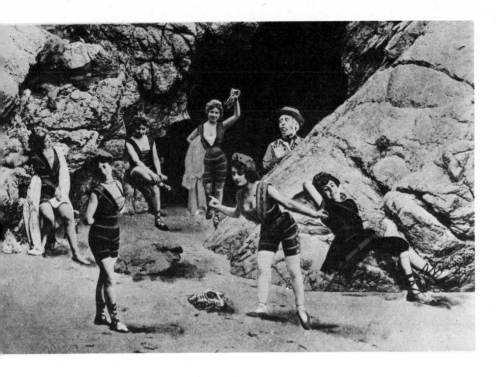

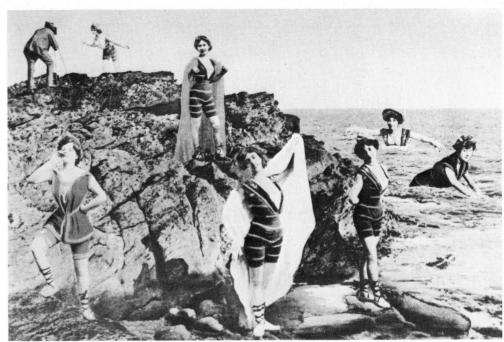

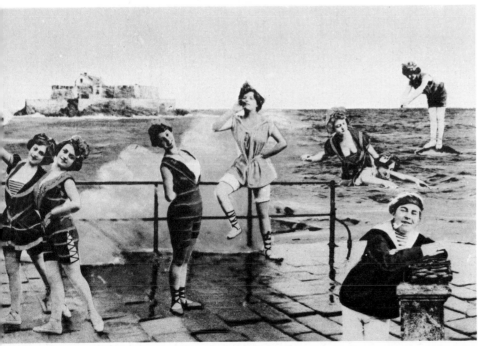

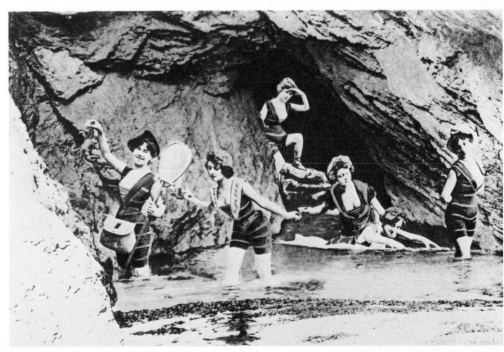

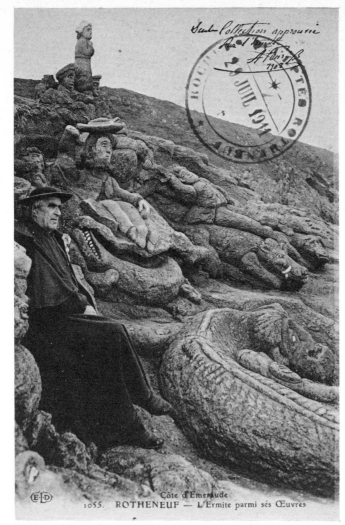

Côte d'Émeraude
1055. ROTHENEUF — L'Ermite parmi sés Œuvres

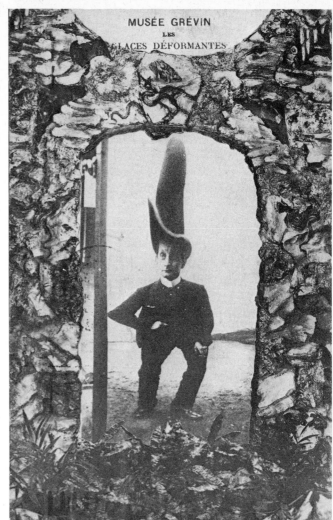

MUSÉE GRÉVIN
LES
GLACES DÉFORMANTES

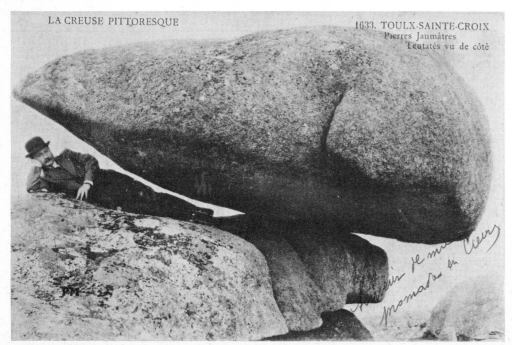

LA CREUSE PITTORESQUE
1633. TOULX-SAINTE-CROIX
Pierres Jaumâtres
Teutatès vu de côté

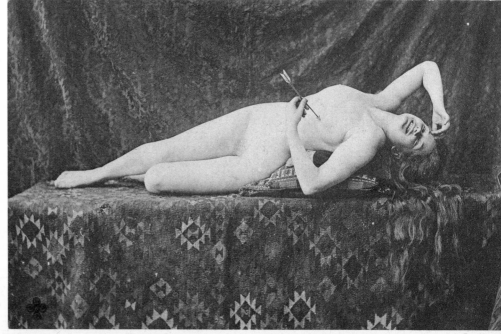

Matron.

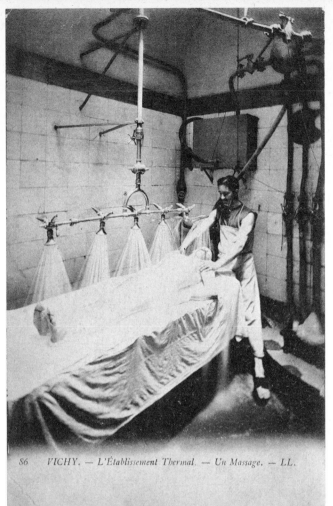

S6 VICHY. — L'Établissement Thermal. — Un Massage. — LL.

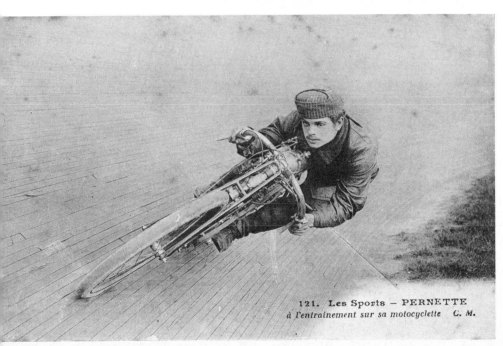

121. Les Sports — PERNETTE
à l'entrainement sur sa motocyclette C. M.

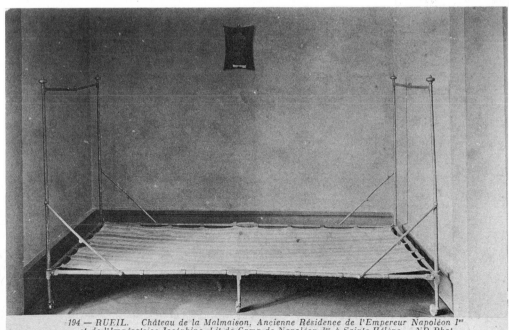

194 — RUEIL. Château de la Malmaison, Ancienne Résidence de l'Empereur Napoléon Ier
et de l'Impératrice Joséphine. Lit de Camp de Napoléon Ier à Sainte-Hélène. ND Phot.

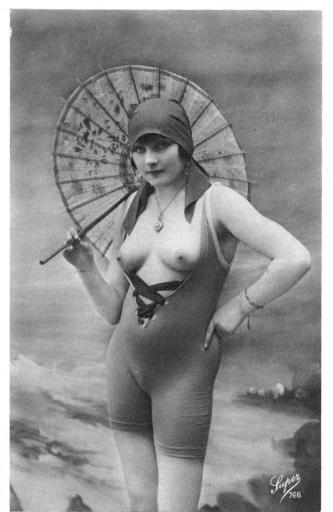

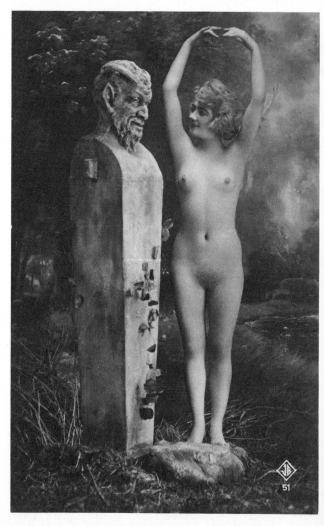

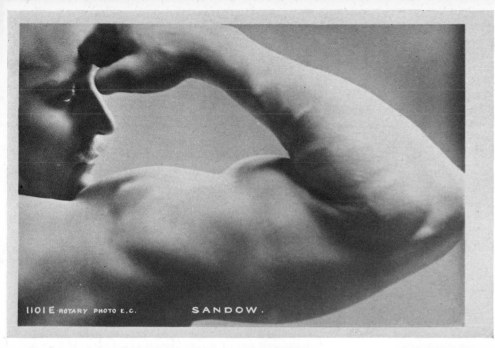

1101E ROTARY PHOTO E.C. SANDOW.

GG
Cº
2005/3

LEBENDER
MARMOR

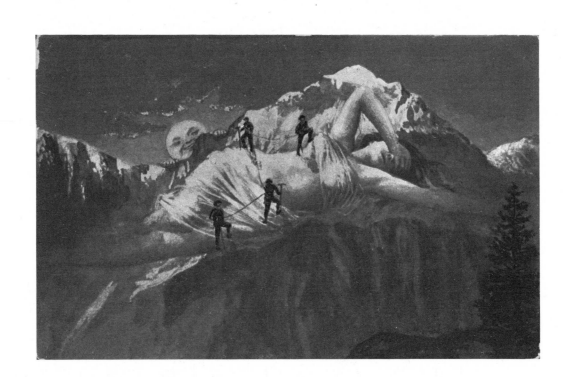

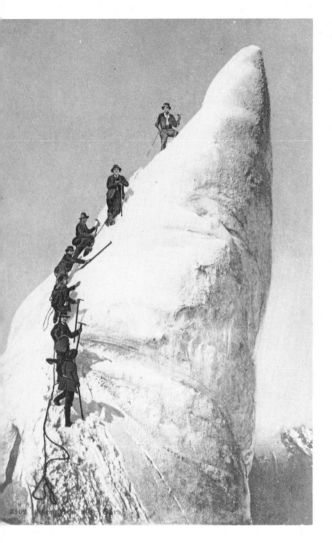

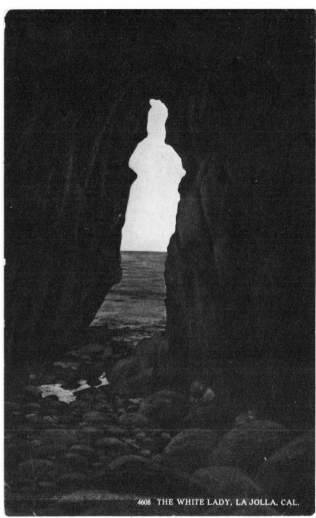

4608 THE WHITE LADY, LA JOLLA, CAL.

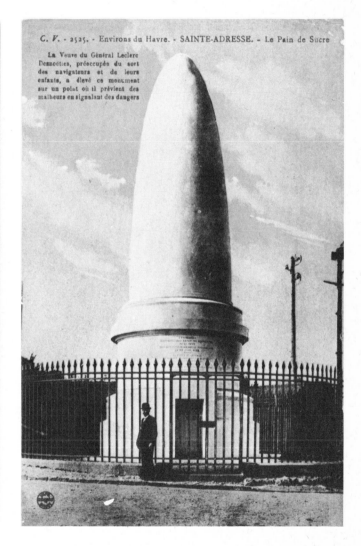

C. V. - 2525. - Environs du Havre. - SAINTE-ADRESSE. - Le Pain de Sucre

La Veuve du Général Leclerc
Desnoëties, préoccupés du sort
des navigateurs et de leurs
enfants, a élevé ce monument
sur un point où il prévient des
malheurs en signalant des dangers

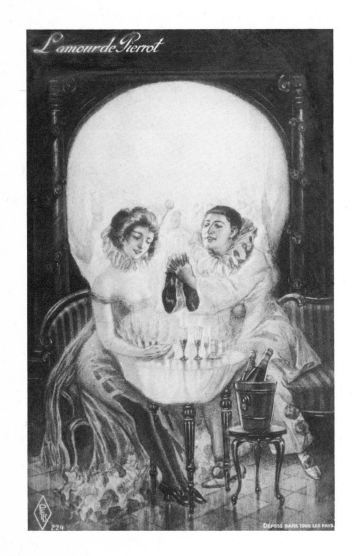

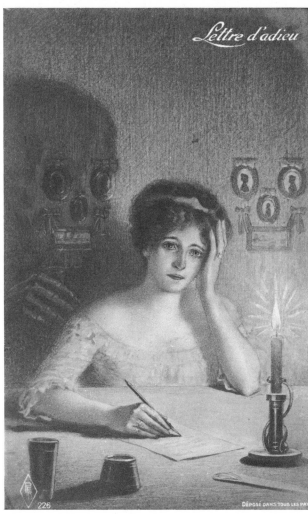

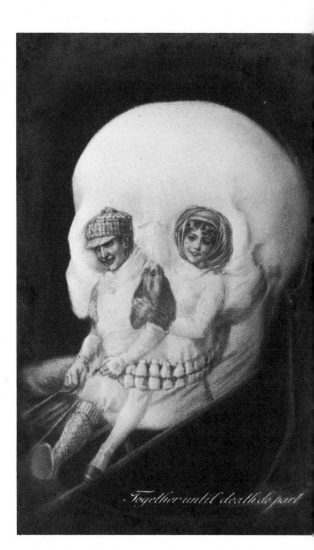

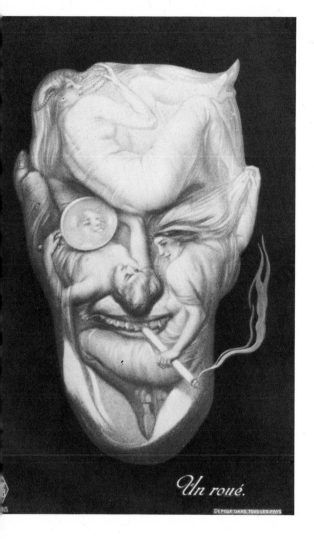

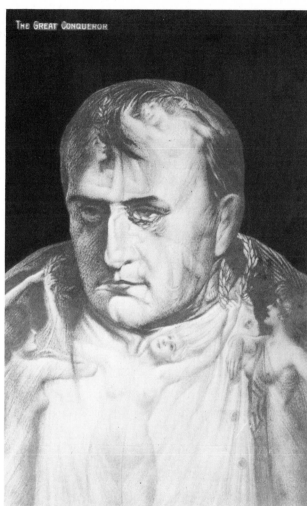

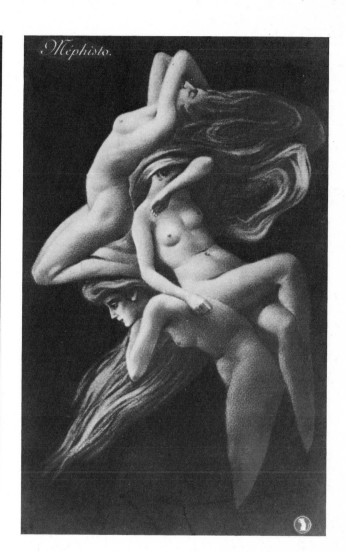

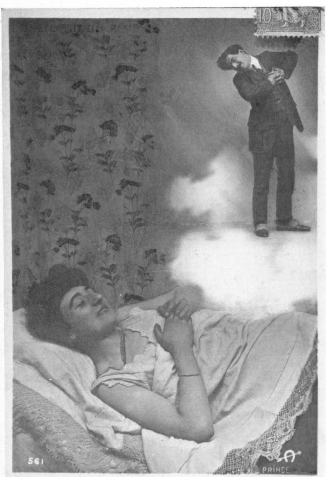

Voila qu il demande sa main
Elle rêve mariage prochain

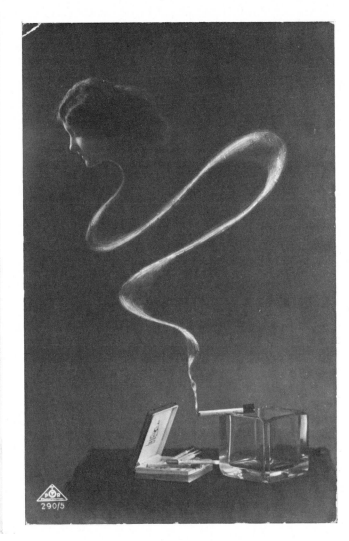

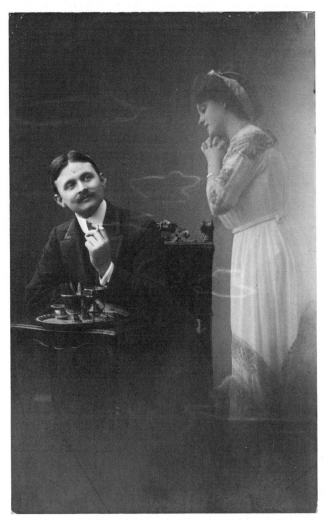

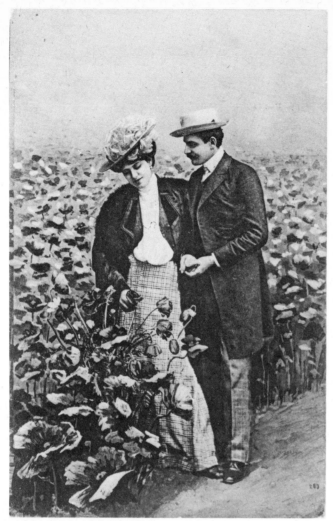

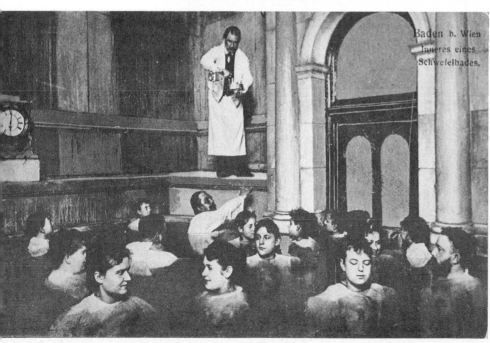

Baden b. Wien
Inneres eines
Schwefelbades.

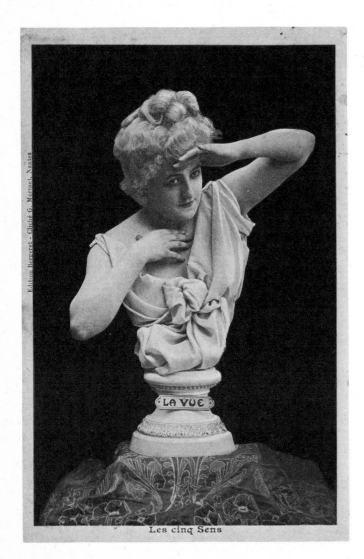

Les cinq Sens

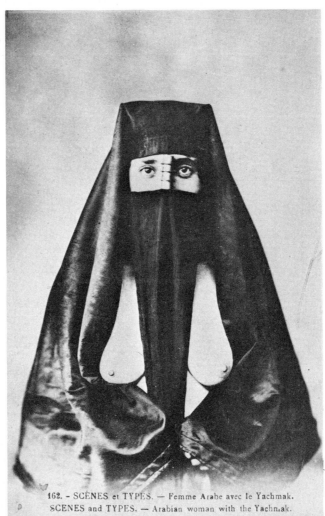

162. - SCÈNES et TYPES. — Femme Arabe avec le Yachmak.
SCENES and TYPES. — Arabian woman with the Yachmak.

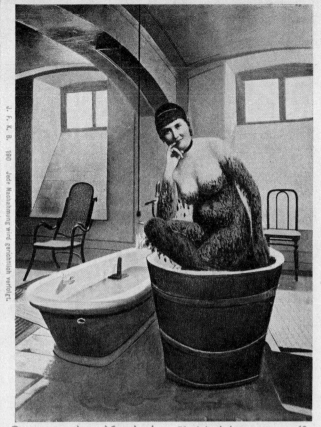

Gruss aus dem Moorbad. Karlsbad den................19

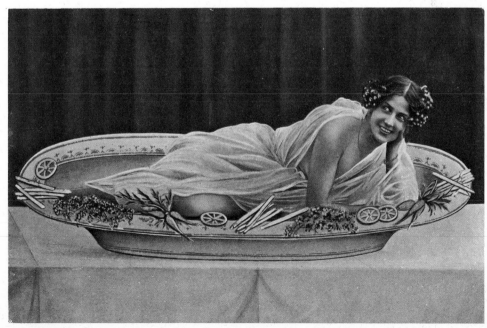

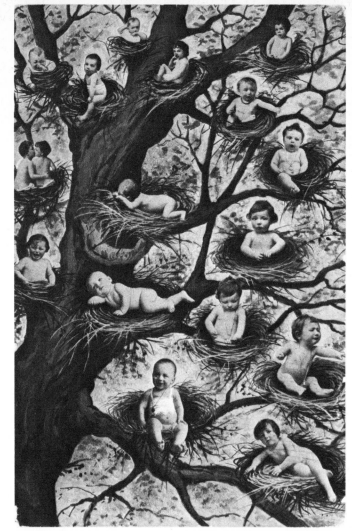

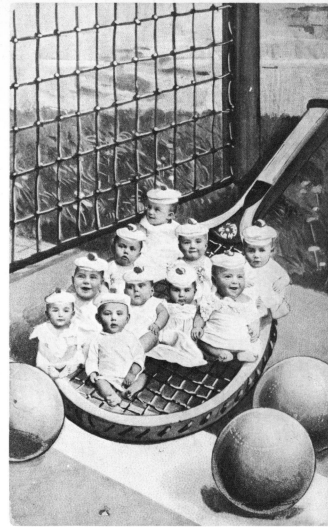

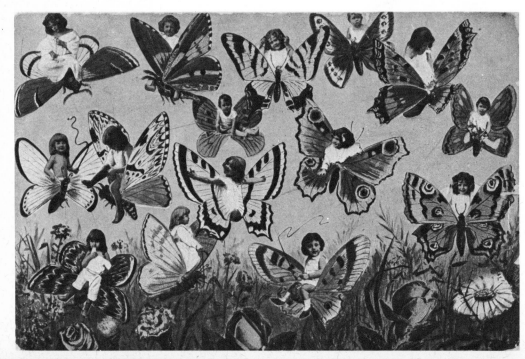

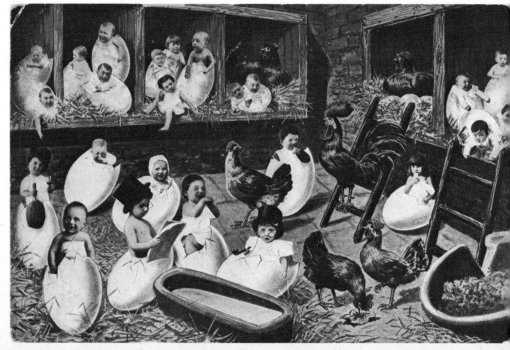

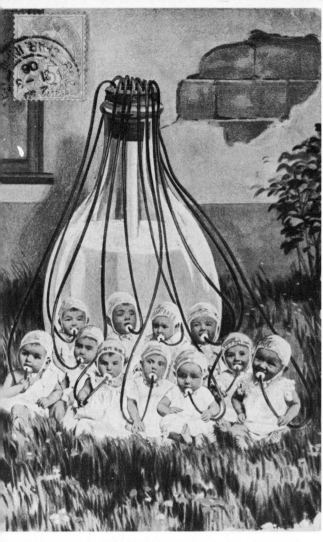

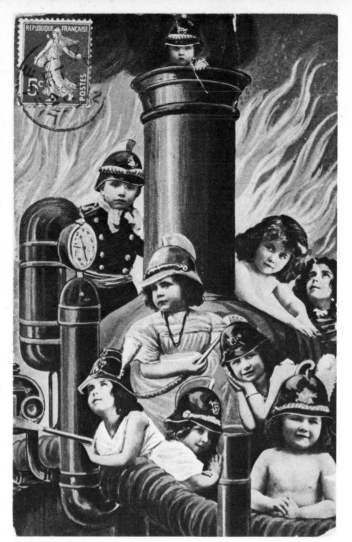

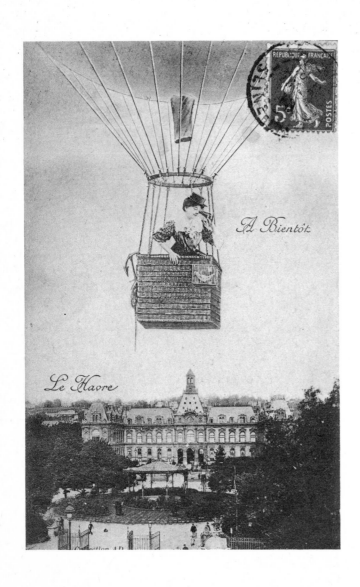

A Bientôt

Le Havre

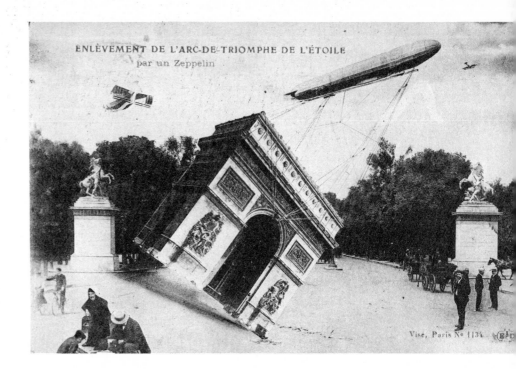

ENLÈVEMENT DE L'ARC-DE-TRIOMPHE DE L'ÉTOILE
par un Zeppelin

Visé, Paris No 1134

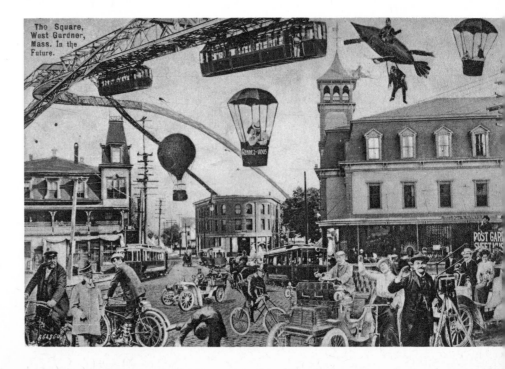

The Square,
West Gardner,
Mass. In the
Future.

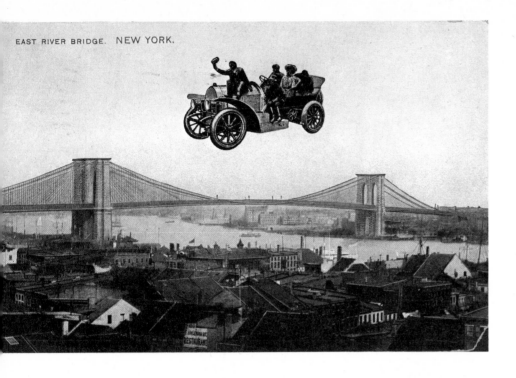

EAST RIVER BRIDGE. NEW YORK.

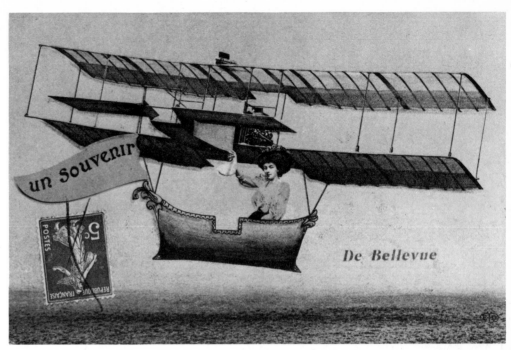

un souvenir

De Bellevue

POSTES 5c RÉPUBLIQUE FRANÇAISE

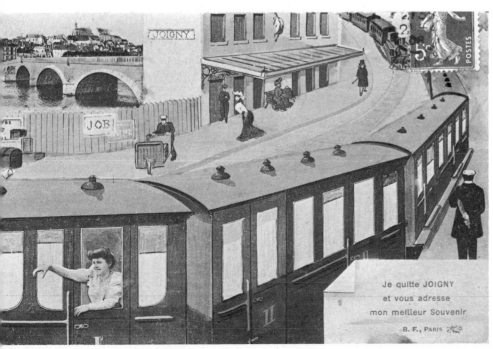

JOIGNY

JOB

Je quitte JOIGNY
et vous adresse
mon meilleur Souvenir

B. F., PARIS

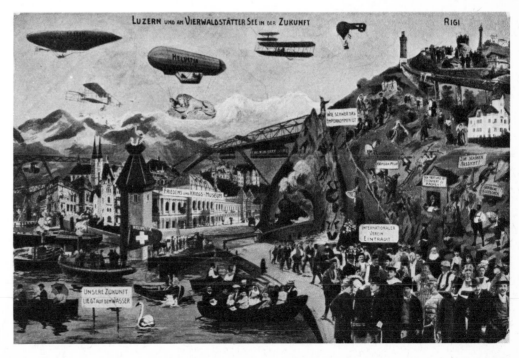

LUZERN und am VIERWALDSTÄTTER SEE in der ZUKUNFT RIGI

HELVETIA

FRIEDENS und KRIEGS-MUSEUM

UNSERE ZUKUNFT
LIEGT AUF DEM WASSER

INTERNATIONALER
VEREIN
EINTRACHT

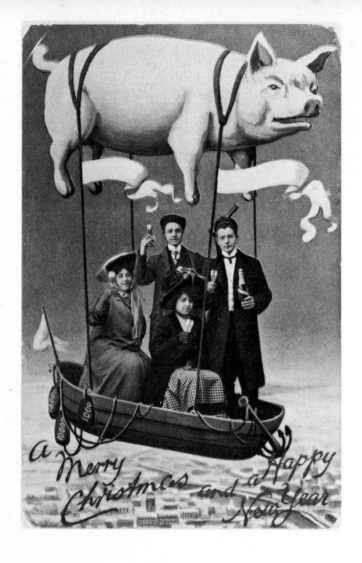

A Merry Christmas and a Happy New Year

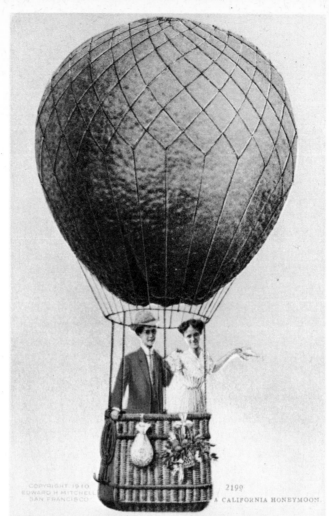

A CALIFORNIA HONEYMOON.

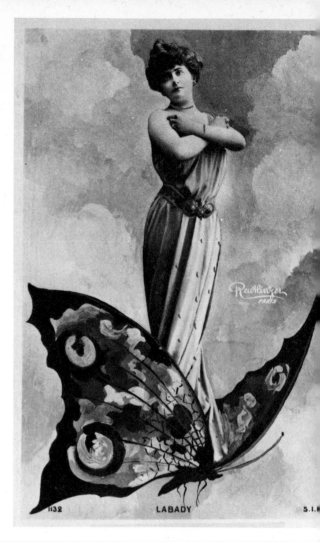

LABADY

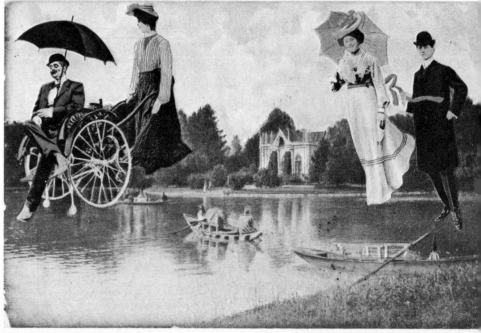

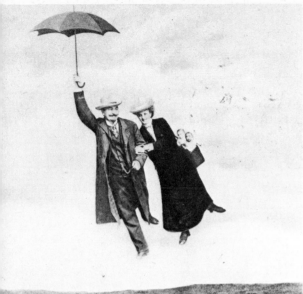

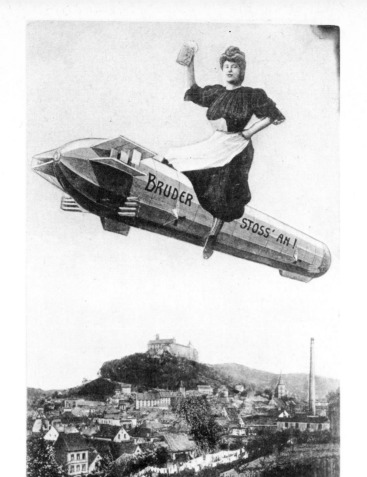

Ein Familienausflug nach Aachen

KULMBACH

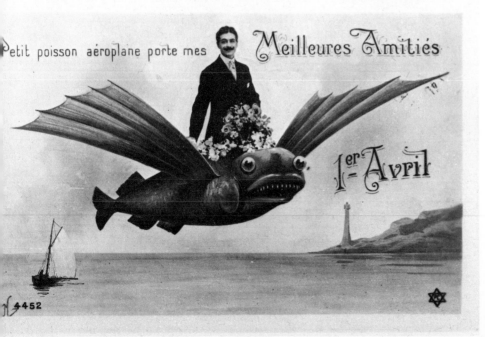

Petit poisson aéroplane porte mes Meilleures Amitiés

1er Avril

N° 4452

En me voyant vous n'avez donc pas l'envie
d'en acheter un comme moi?

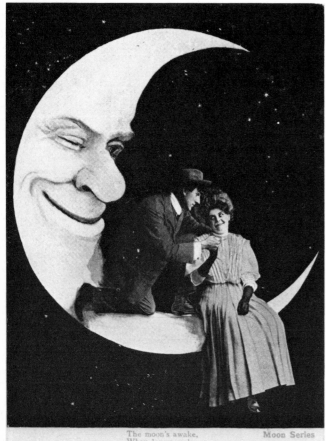

The moon's awake,
When lovers make,
Confession shy;
All eyes and ears,
He sees and hears,
And looks so sly,
I really think
I've seen him wink,
The other eye.

Moon Series

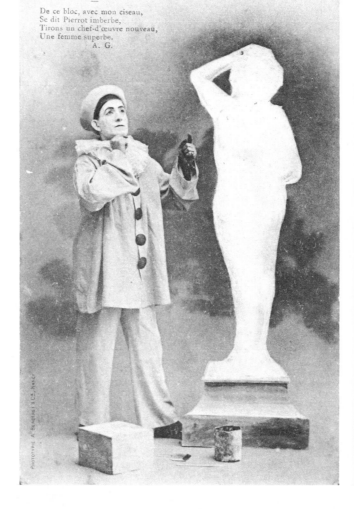

1. — Pierrot sculpteur
—
De ce bloc, avec mon ciseau,
Se dit Pierrot imberbe,
Tirons un chef-d'œuvre nouveau,
Une femme superbe.
A. G.

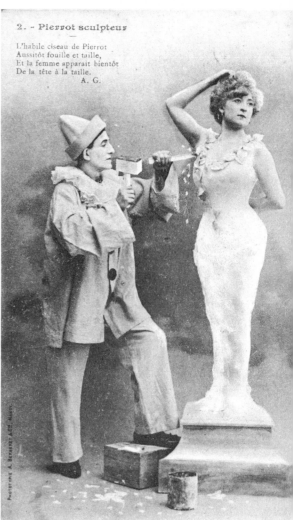

2. — Pierrot sculpteur
—
L'habile ciseau de Pierrot
Aussitôt fouille et taille,
Et la femme apparait bientôt
De la tête à la taille.
A. G.

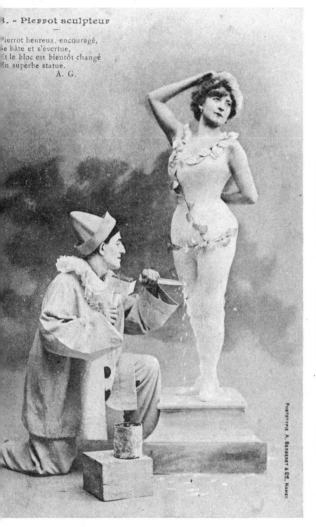

3. - Pierrot sculpteur

Pierrot heureux, encouragé,
Se hâte et s'évertue,
Et le bloc est bientôt changé
En superbe statue.
A. G.

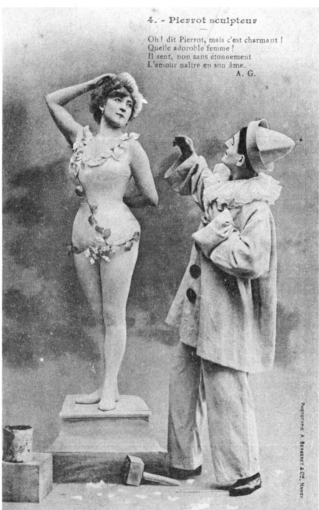

4. - Pierrot sculpteur

Oh! dit Pierrot, mais c'est charmant !
Quelle adorable femme !
Il sent, non sans étonnement
L'amour naître en son âme.
A. G.

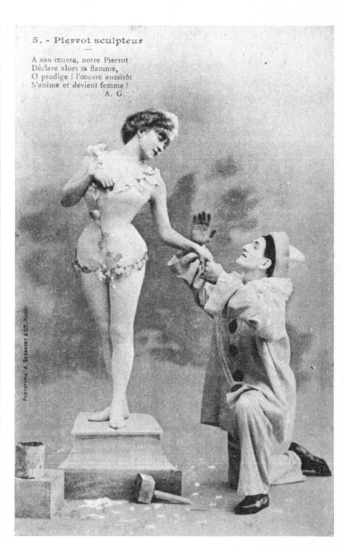

5. - Pierrot sculpteur

A son œuvre, notre Pierrot
Déclare alors sa flamme,
O prodige ! l'œuvre aussitôt
S'anime et devient femme !
A. G.

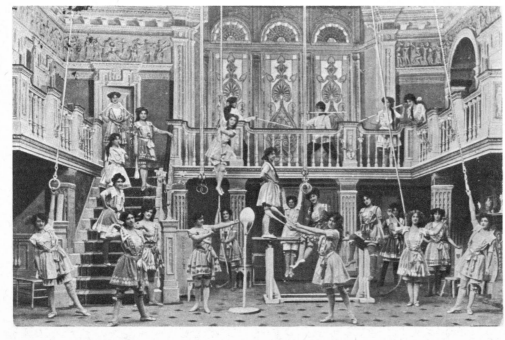

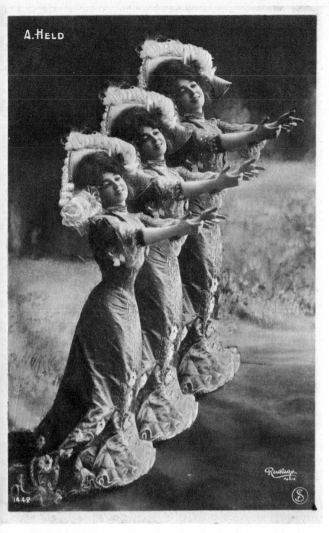

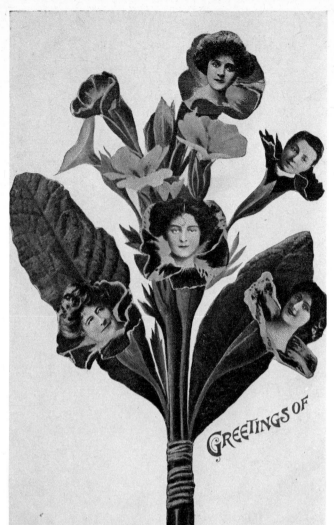

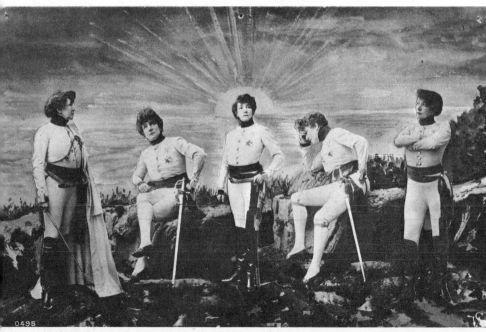

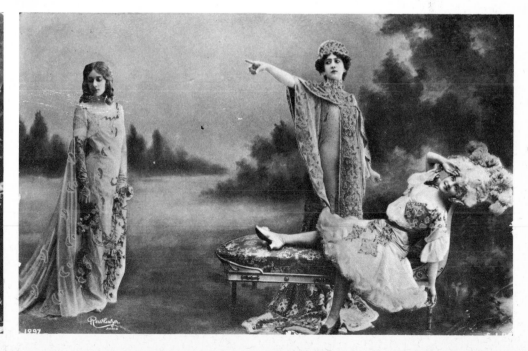

76

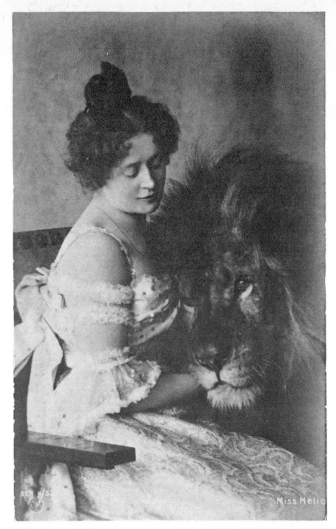

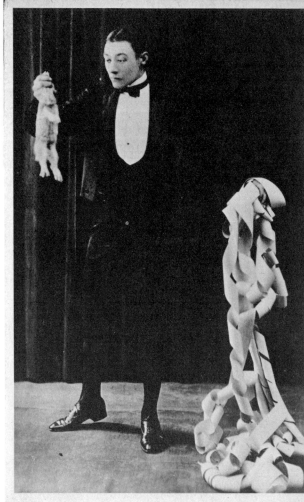

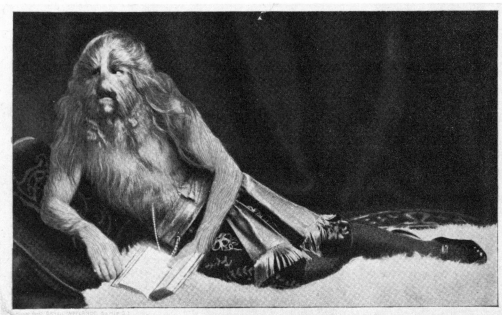

Andenken an Lionel, den Löwenmenschen,

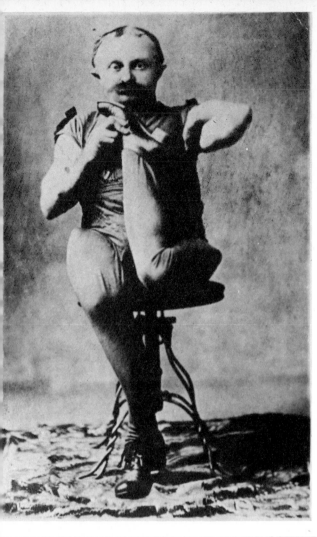

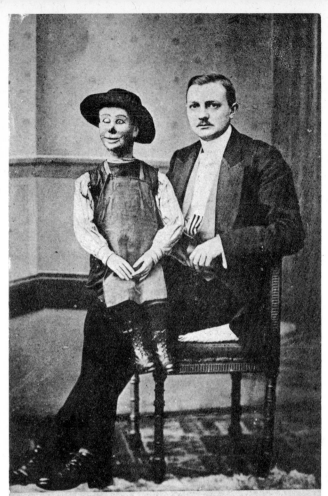

Fred C. Elman :: Humoristischer Ventriloquist

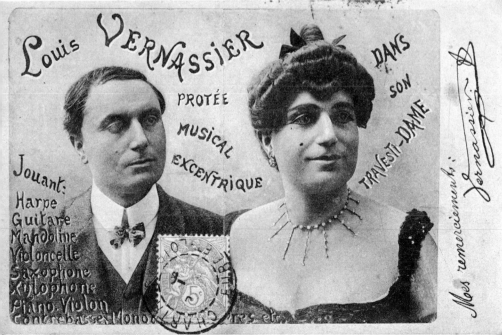

Louis VERNASSIER

PROTÉE MUSICAL EXCENTRIQUE DANS SON TRAVESTI-DAME

Jouant:
Harpe
Guitare
Mandoline
Violoncelle
Saxophone
Xylophone
Piano Violon
Contrebasse Monolo...res etc...

Mes remerciements: Vernassier

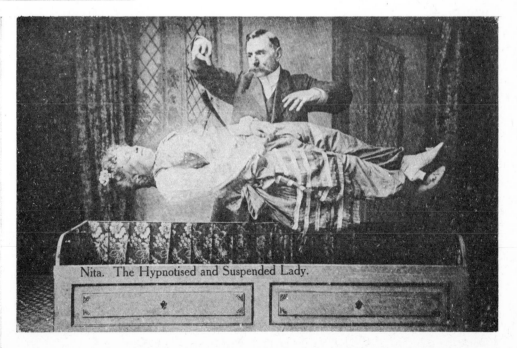

Nita. The Hypnotised and Suspended Lady.

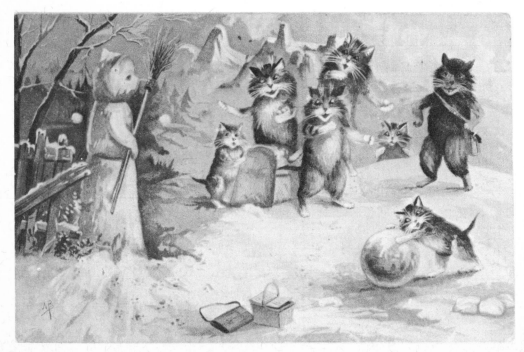

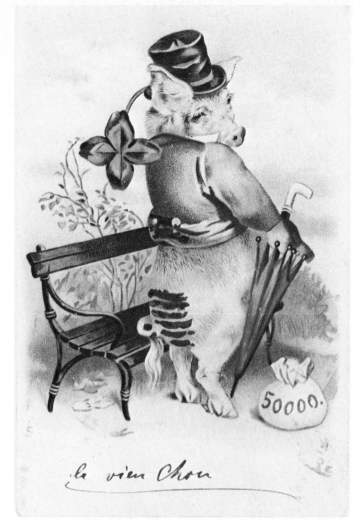

le vieu Chou

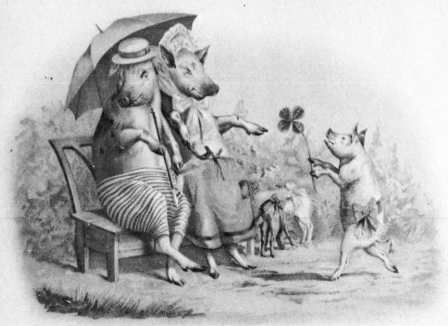

A happy Christmas to you.

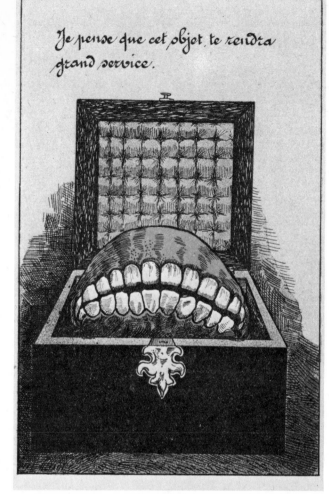

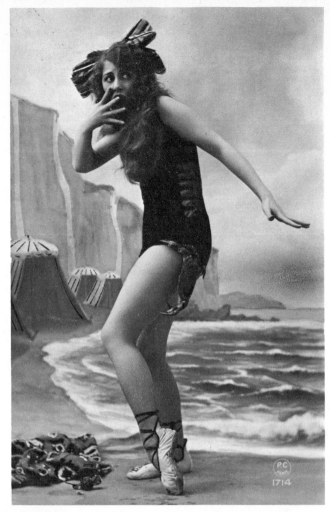

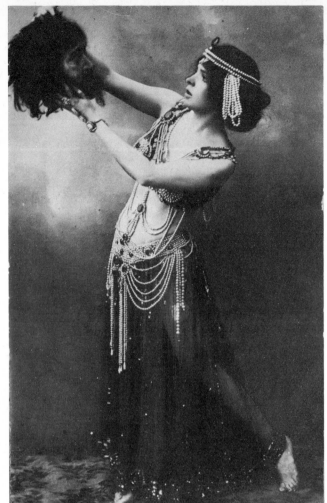

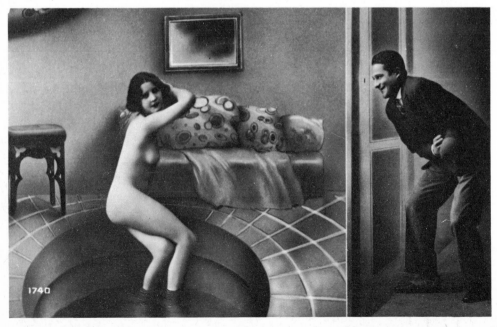

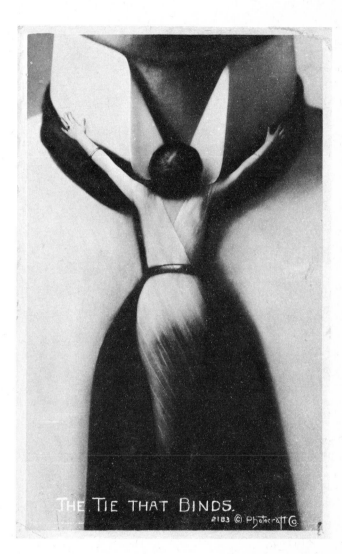

THE TIE THAT BINDS.

2183 © Photocraft Co.

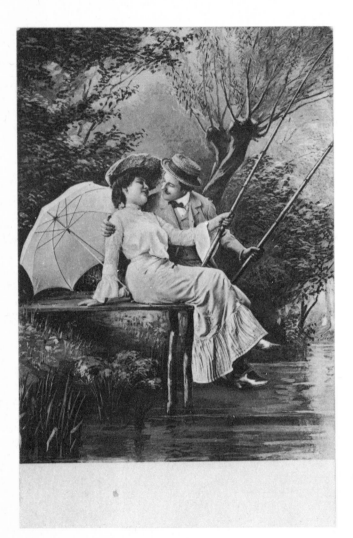

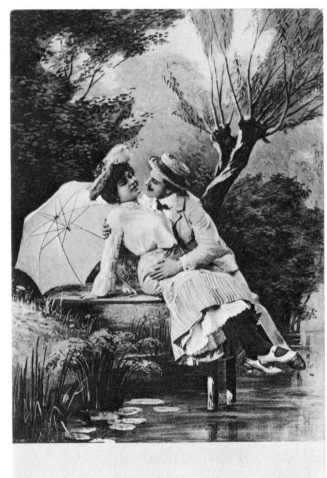

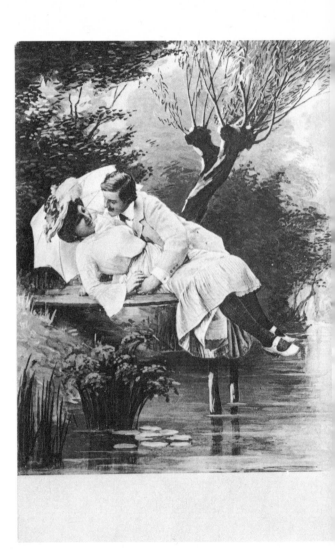

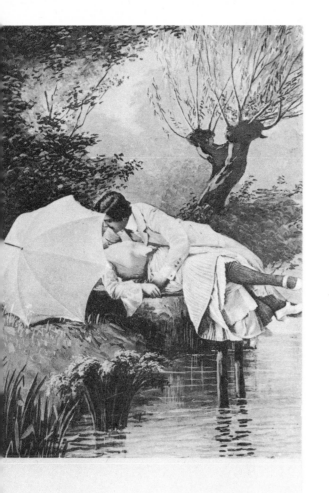
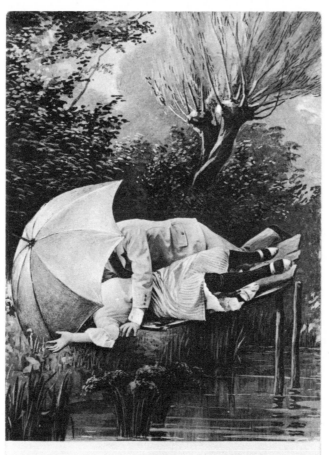
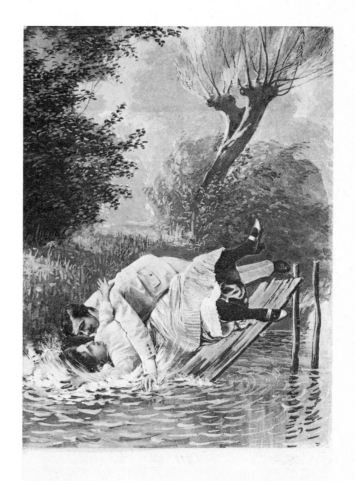

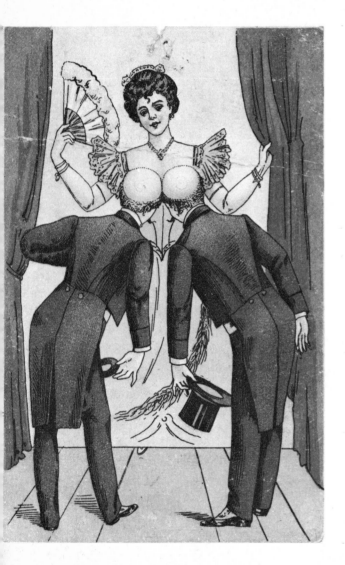

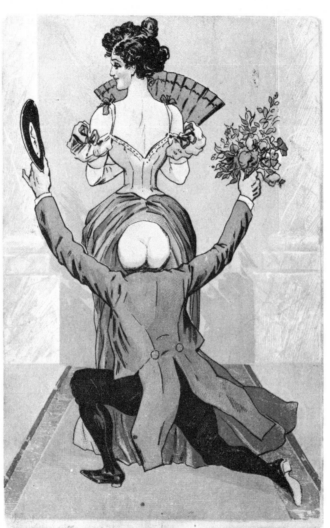

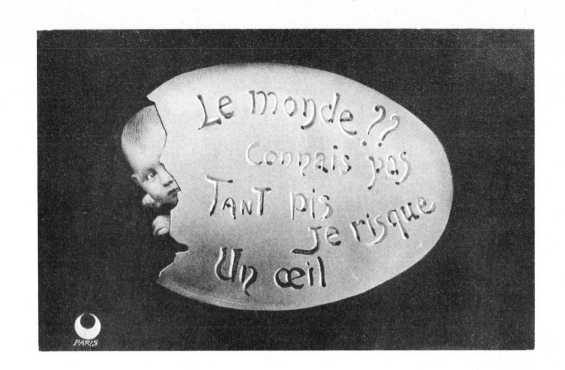

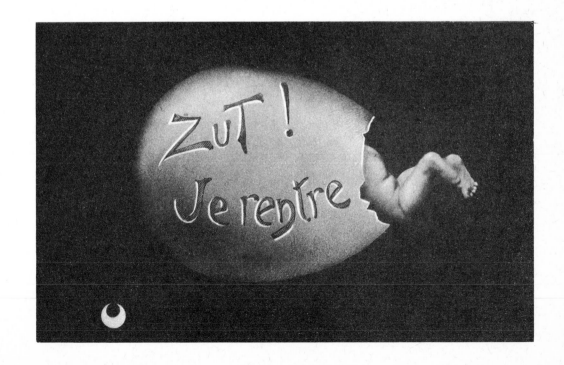

Each postcard or series of cards is identified, whenever possible, by the following information: title; method of reproduction and materials; series designation; artist; country of manufacture; publisher; date of manufacture, and postmark or date of message, in that order. The date of manufacture has been determined by whether the card has a divided or undivided back, and relates to the year when the respective country adopted the divided back. Hence, in France, 'pre-1904' indicates undivided; 'post-1904' indicates divided. Where this system gives dates too far removed from the probable date of origin, this date has been given, or guessed at, and the word 'circa' has been used.

The numbers heading the notes refer to the pages on which the cards appear.

16

Masked Woman (*La Femme au Masque*)
collotype; 1st of a series; France; circa 1900

Masks are associated with mystery and intrigue; they are substitute faces which conceal what is and suggest what might be. Here, drapery serves a similar dual purpose; an 'artistic' touch, a reference to classical times, perhaps, but also concealing and revealing the woman's body.

The Sense of Smell
photograph; from a series; France; postmark Chambery 11/25/1905

Pierrot and Columbine, treated here with great charm, often appear on French cards and, along with other subjects ranging from the five senses to the Ten Commandments, served publishers as pretexts for endless postcard series.

Nymphs
photograph; 1st of a series; Germany; NPG; pre-1905

Montage artists often produced fantasies by reworking subject matter already used for another purpose. Here, shots of actresses and models, originally published separately, are combined in a fine photomontage by one of the better German publishers. The same pose of French soprano Emma Calvé, here seen negotiating a back stroke, also exists in a series of close-ups, still draped in Ophelia flowers, but standing upright, waist deep in a different hand-painted lagoon.

Musical Notes
tinted photograph; from a series; France; A.N. Paris; postmark Paris 7/3/1905

Fantasy music to be seen and not heard. The cards in this particular series do not combine to form a tune, although this would have been a typical fantasy postcard notion.

17

Water Nymph (*Les Ondines*)
tinted photograph; 1st of a series; France; Reutlinger; postmark Paris 6/?/1903

A stock studio pose of Anna Held, Ziegfeld's celebrated star and spouse, is transformed into a water nymph by the clever retoucher.

The Shy Moon
tinted photograph; from a series; France; Raphael Tuck et Fils, Paris; postmark Monte Carlo 7/16/1906

Journey of the Bells (*Voyage de Cloches*)
tinted photograph; 5th of a series; France; Reutlinger, Paris; postmark St Seine L'Abbaye, 4/2/1904

During the Belle Epoque, the firm of Reutlinger specialized in photographing beauties of the theatre world, famous and infamous. Besides straight portraits and prints, they produced many interesting photomontages such as this one, from a series of actresses as winged bells. One puzzles over the origin of this startling metaphor, at the matter-of-fact visual treatment contrasted with the sophistication of its message — the images of night, space, of ringing, resonance and flight as an expression of feminine beauty.

Crescent Moon
photograph; France; postmark unclear, message dated 11/1/1911

Here Pierrot and Columbine are joined by the other traditional protagonist in their story, the moon. 'My Columbinette, I love your eyes, your long silky eyelashes and your ruffles.'

18-19

Intentional fantasies of this sort generally require no comment. They convey their meaning today as clearly as when they were first sent.

18

Tulip Faces
chromolitho; Germany; E.N.; circa 1910; postmark Broadstairs, Kent (England) 4/22/1924

Just Arrived
chromolitho; Germany, for International Postal Card Co, Chicago; postmark Rodney, Mich. 8/4/1908

Souvenir
chromolitho; Germany; postmark La Roche Gare, (France) 4/26/1906

Ping Pong in Fairyland
chromolitho; 2nd of a series; Saxony, for Raphael Tuck & Sons; pre-1902; postmark Hampstead (London) 9/16/1904

19

Candle and Biscuit
chromolitho; Germany; postmark Portugal, date unclear, inscribed date 12/24/1904

Umbrella of Violets
chromolitho; Germany; postmark Sarthe, Change (France) 8/7/1908

Flower Telephone
chromolitho; Germany for Raphael Tuck & Sons, England; postmark Dundee 4/14/1902

Acorn Faces
chromolitho; England; Delittle Fenwick & Co, York; postmark Llandrindod-Wells 6/15/1908

20

These three fantasies require the physical participation of the viewer.

Love's Talisman
photograph; France; circa 1920s

Upon reversal, this witty 'playing' postcard nicely repeats its photomontage message.

Patience and a Long Time
collotype; France; postmark Ostende Station 9/12/1901

To read the message on this card we are forced to turn it in all directions, physically involving ourselves in the charming art nouveau design and retracing its curves, experiencing while reading it what the sender must have felt while writing it. The message reads

Souvenir d'Ostende: I hope you will not think me an awful nuisance for sending you this card to tire your patience but I thought it would be something original for your collection. We are having a very nice time here and lovely weather. We left Copenhagen last Sunday at 12 a.m. and arrived here Monday at 5 p.m. I hope you have had a merry time in Eastbourne. With much love from your troublesome little cousin Violet Levy. Splendid Hotel, Sept. 18th, 1901.

Let Us Prey!
chromolitho; England; circa 1914

This joke at the Kaiser's expense is a double pun, both verbal and visual, revealed much in the manner in which it was originally concealed; the verbal and visual meaning is literally and physically reversed or turned on its head.

21

These puns, so beloved of the English, are double appealing for being visually illustrated.

A Pig-uliar Card From London
color photolitho; from a series; Germany; Rommler & Jonas, Dresden; postmark 9/17/1905

Upon My Sole
color photolitho; US; Bamforth Co, Mohegan Lake, NY; circa 1910

Just a Card to Let you Sea-Weed Arrived
color photolitho; England, Wildt & Kray, London; postmark Folkestone 7/16/1914

22–23

Mechanical and transparency cards are, by their nature, fantasies which deal in time and motion. The mechanical card is composed of several cleverly contrived parts which spring to action when we pull a tab, turn a wheel, or lift a flap, changing the image instantly before our eyes.

The apparently normal printed face and blank back of the transparency are in fact separate sheets glued together to conceal secret printing. When held up to a bright light the image on the front of the card is altered in some unexpected way. Unlike the mechanical card, the transparency may change gradually, say from day to dusk to night, and back again from night to dawn to day, creating a cycle.
Both have a dual nature, combining antithetical ideas, times or objects in a single card. The dual ideas remain incomplete until the viewer intervenes, actively revealing their message, like a conjuror, by legerdemain. Surprise is the key; in the moment of transformation it disarms our logic and scepticism and, childlike, we delight in being fooled.

22

Hunter into Hunted
chromolitho; Germany; circa 1910

Though the image of the hunter instantly transformed into his prey is an irresistible interpretation, this man's horns might also be those of the cuckold.

The Lady and the Gentlemen
chromolitho; Germany; circa 1910; Collection of Florence Wasserman

Here the dual concept of the mechanical card is aptly used. The before and after versions might be waking-life versus nightmare; the act of transformation reveals the thin line between these two states. One can interpret the rich and ambiguous results as one would a dream.

Monkey into Geisha
color process; from a series; Japan; pre–1906

The oriental love of contour is the basis of this subtle visual paradox, wherein the idea and the process which reveals it are inextricably and perfectly combined. Complex shades of meanings are revealed through the transformation: ultimately the image is not only a monkey and not only a geisha, but the sum of the two, together with all of the questions and ironies which their combining poses, Animal into human, ugly into beautiful, simple into complex, natural into artificial, ridiculous into sublime? It is a perfect fantasy cycle, for the beauty just as easily turns back into the beast.

Pier and Sands, New Brighton
chromolitho; 3rd of a series; Prussia, for England; circa 1903

In operation, this straightforward transparency card is a fine example of the gradual transformation cycle: as the sunny day changes to stormy dusk, the rainbow appears and then disappears again as the sun returns.

24–25
Words very often create visual images; here, visual images literally create words. Images within images imply that an object can symbolize or literally encompass a place. The object, in a sense, *is* the place; for if Gotha evokes the sausage, the sausage evokes Gotha.

24

Hamburg in a Sole
chromolitho; Germany; postmark Poplar, (London) 9/5/1905

Paris in Babies
chromolitho; Germany; postmark Paris 11/5/1905

Gotha in a Sausage
chromolitho; Germany; A. Gimm, Gotha; postmark Gotha 8/29/1906

Best Wishes for 1907 in People
Germany; postmark Columbus, N.J., (U.S.A.) 12/31/1906

25

1908 in Snowmen
chromolitho; Germany, US overprinting

Interlaken in a Bear
chromolitho; Switzerland; postmark Spiez 4/23/1914

Rose in Roses
chromolitho; Saxony, for B.B., London; circa 1910

This statement, rose in roses, is literal, obvious, banal – and quite perfect. The card, like the taste of madeleine, evokes Marcel Duchamp, who despised the name Rose yet christened his fictitious alter-ego Rrose Selavy, adding the extra 'r' because of his fascination with the name Lloyd.

Heinz Pier in a Pickle
chromolitho; Germany, for Souvenir Post Card Co, New York; postmark Atlantic City, 9/13/1908

Heinz Pier, of the 57 varieties, was one of the major attractions of the boardwalk at turn-of-the-century Atlantic City. At this time, both the pier and the Heinz pickle trade mark were so well-known that any mention of them on this card was unnecessary.

26
Postcard novelties with applied objects can sometimes enter the realm of fantasy.

Girl with Bodice and Coiffure
tinted photograph with applied real hair, chenille and silk flowers, spun glass, silk bodice, glitter; 1st of a series; Germany; post-1905

Though we can accept individually the real hair, real cloth, flowers and spangles, and the photograph of a real girl, their combination on this postcard creates an intensely *unreal* effect. Was the illusion of reality actually intended? Were we meant to exclaim: 'How lifelike!'? One suspects, in fact, that the required reaction was less demanding, one should have exclaimed simply: 'How beautiful!'

Bicyclist
chromolitho with applied tissue bloomers; Germany, pre-1905

The woman's expanding tissue buttocks are a nice example of the fantasy of tangibility.

Dancer
tinted photograph with applied silk skirt; France; P.H.; circa 1920s

If a pin-up is a fantasy substitute for the real erotic object, this one literally achieves a new dimension by the application of a little piece of silk. By involving the participant physically, this card provides him with a substitute version of real-life lifting and peeping.

27

Balanced Rock, Pittsfield, Mass
collotype with wired-on rock; Germany, for The Rotograph Co, New York; message dated 7/28/1906

This extraordinary postcard is a form of art wherein the sender, an intrepid climber and adventurer, imaginative and obsessively concerned with detail, has documented his experience in an immediate, creative and quirky way. His contribution is enhanced by other, retrospective, fantasy considerations. His self-drawn image sits on an image of the rock at the very moment he actually sits on the rock itself. His drawn self is accompanied by two women whom he can never have seen, and who were possibly photographed many years before the card itself was made. The message reads, exactly as written

> Dear Parents, Brother and Friends:
> (the following arising from the mouth of a little man in a broad-brimmed hat sitting on the edge of the rock.) I am at this minute sitting ('x' indicated) in almost the exact position you see me here facing the south. I have my pencil in my hand writing *now*, having just finished drawing my likeness. This rock is situated about 5 miles north of Pittsfield and is about 30 feet across the face which confronts you. It's height is about 20 ft. and its depth from front to back of this face is about 25 ft. It is an emense large rock pure white of which I will endevor to send you a piece. This bolder is 8 times as large as the Crouce Boulder and seems to set on a base not larger than a boiler bottom and something that shape about 18 by 30 inches. It is now exactly 1:45 July 28 1806. By turning to the left I get a fine view of Graylock Massachusetts' highest peak. This field is scattered with very large rocks of this kind of stone. *Arlo S. Purchase*

Other random notes on the card

> . . . *(two unclear words)* arent pleasant but I wish they were I have taken 9 orders this A.M. Helen and I were here June 10, 1913 on our Honeymoon. *(In ink, in the same hand, but possibly a later date.)*

Indications of exact places

> This is the tree from which the leaves and twig came *(over tree on the left)*
> I wrote my name here with a key *(upside-down, in facsimile)* ARLO S. PURCHASE *(also, in a circle)* ARLO
> *(Along inner crack on rock)* The piece wired on below was chipped off where you see the cross *('x' indicated to right)*
> Books *(above drawing of books on top of rock)*
> my shoes *(two shoes on a rock foreground left)*
> my wheel *(drawing of a bicycle, large rock foreground)*

S.S. Canopic
photolitho; Italy; E. Ragozino, Naples; postmark 'paquebot' Boston, Mass. 4/28/1906

The sender has scribbled the storm at sea which she has just experienced over an idyllically placid tourist view of her ship. Her message reads

> Had to redraw this card to fit out conditions – Three days of gale – But everyone is alive this morning. It's worth while for this. Have not been very unhappy. Ethel.

The Road
hand-painted, with applied postage stamps; France; pre-1904

Postage stamp pictures were often produced by nuns and this postcard could well be the product of convent industry. The walker with his cane – a blind man? – seems headed for oblivion; the road disappears around the bend.

Birchbark Scene
hand-drawn design on birchbark signed R.S.; US, circa 1910

This card was home-made from birchbark, just like the canoes which were part of the glamorous Indian legend. It might be titled 'The Return of the Chief'.

28–29
The idea of the series is basic to the thinking behind postcards. Several poses or views were produced of most subjects and often packaged together, under the wise and profitable assumption that it would encourage people to buy extra cards. Series usually number from two to ten, but some have been known to run to twenty-five or more. 'Instalment' cards are those which have a consecutive order, such as the groups pictured here. They were usually sent one at a time until the arrival of the last card of the series completed the picture message. Sometimes, individual cards of an instalment series composed a single picture when viewed together. These were often sent out of order to tease and puzzle the recipient, resulting in a game two people could play by post, the element of time adding to the suspense.

28

Rabbit Hunting
collotype; 5 from a series of 5; France; Bergeret et Cie, Nancy; circa 1904

This series is typical of Bergeret's work (see p.14) with its studio setting, stylized theatrical gestures and verses, and light, romantic mood.

The Fish Story
chromolitho; 3 from a series of 3; US; Wildwood Post Card Co, Wildwood, New Jersey; 1906. Postmarks: head – Atlantic City, New Jersey, 10/1/1906 6 A.M. (postmark received Haddonfield 10/1/1906 8 A.M.); middle – Atlantic City 10/1/1906 9.30 A.M. (received Haddonville 10/1/1906 4 P.M.); tail – Atlantic City P.M. (received Haddonville 10/2/1906 12 midnight); sender's dates on card: head 9/29/06, middle 9/30/06, tail 10/1/06

The detailed postmark information is included to demonstrate that each portion of the fish was sent separately and that the US Postal Service was remarkably efficient at the time.

30

A Girl for Every Day of the Week
chromolitho; Germany; post-1905

Watermelon Auto
chromolitho; Germany, for International Art Publishing Co, New York; 1904

Easter Greetings
chromolitho; Germany; post-1905

Cupid and Rose
chromolitho; Germany; post-1905

31

Baby Bouquet
chromolitho; Germany; pre-1905

Easter Bunny in Auto
chromolitho; Germany, for H.I. Robbins, Boston; 1907

Your Choice
chromolitho; France; pre-1904

Babies on Fish
chromolitho; France; post-1904

32

On Duty!
chromolitho; England; circa 1905

Toilette
chromolitho; signed A. Vimaz; France; pre-1904 (circa 1900)

Puss-in-Cuff
chromolitho; initialled E.T.; Germany; C.P.F.; inscribed date 1/12/02

33

Hippo Family
chromolitho; Bavaria, for Ernest Nister, London; postmark Red Hill 2/13/1905

Emerging Chick
chromolitho; Germany; postmark Neuilly-sur-Seine, Seine (France), 4/11/1905

Frog Serenade
chromolitho; initialled D.L.; France; G & L, Bollag, Colmar; postmark Darlington, England 7/1/1904

34
These fantasy designs are by Raphael Kirchner, a turn-of-the-century artist, working in the art nouveau style, who was well-represented on postcards.

Pink Ladies
chromolitho; from a series, signed Raphael Kirchner, Paris; Germany, for Raphael Tuck & Sons, England; post-1902

Lady with Sunburst
chromolitho; Raphael Kirchner; Germany; circa 1905

Blue Ladies
chromolitho; from a series, signed Raphael Kirchner, Paris; Germany, for Raphael Tuck & Sons, England; post-1902

35

A Thought *(Une Pensée)*
tinted photograph; initialled C.L.; France; J.K. with arrow; message dated 8/20/1907

'A pansy from your daughter and grand-daughter, Yvonne and Marie.' In France, to send a pansy is to send a thought; they are the same word.

Egg Lady
chromolitho; Germany; postmark Russia 4/3/1908

Bubbles
tinted photograph; Germany; N.P.G.; circa 1905

36

The Wivern
collotype; France; E. Hatin, Compiègne; 1911

A wivern is a fictitious two-legged winged creature with the head of a dragon and the body and tail of a serpent, though this version from Compiègne lacks wings.

Swan Chariot
collotype; France; E. Mary-Rousselière, Rennes; 1913; postmark Montsecret-Vassy 1/7/1914

The Tango Queen
collotype; France; 1914

The Queen of Nourishment
collotype; France; 1911; postmark Nantes 5/2/1911

The Queen of Nourishment, one Mlle Macé, and her ladies-in-waiting appear to be riding a giant 'petit-beurre' biscuit, one of the wings of this fantasy flying fish.

37

The Great Wheel of Paris
chromolitho; signed Paul; France; postmark Paris 8/13/1900

The title refers to La Grande Roue, a giant 'Ferris Wheel' built for the 1900 Universal Exposition in Paris; it is also a play on words, the phrase *faire la roue* meaning 'to turn cartwheels, to spread its tail, to strut'. The Great Wheel of Paris was 100m high and appears to be a close copy of one erected at Earls Court in London in 1894, which was 280ft in diameter and accommodated 1,200

people in 40 huge carriages. The whole machine was operated by two 50hp motors.

Her Return!
photograph; France; message dated 12/28/1913

In 1911, Mona Lisa left the Louvre under the arm of an Italian painter, Vincenzo Perugia, who took her back to Italy where he felt she belonged. This card, picturing the pair and their 'little stranger', commemorates her eventual return from Florence in 1913.

Allegory
tinted photograph; France; E.M.; circa 1914–17

The Sower, a traditional symbol of France, seems to be replenishing the army by bestowing little soldiers on returning veterans and their women.

38

Embrace
tinted photograph; France; A. Noyer; circa 1920s

The real lovers inhabit their own imaginary land, furnished with an art deco sky and a white cartoon balloon, presumably for exclamations of love.

Tears
tinted photograph; Italy; circa 1920s

The anguish, strangely tinted, the heightened tears, the oddly chic eyebrows and distraught hands, thinly veiled, contribute a pervasive feeling of the surreal to this otherwise absurd portrait.

Bride and Groom
tinted photolitho; Germany; circa 1910

The superimposed rainbow elevates a conventional black and white bridal scene into another realm — a rosy spectrum of marriage-as-a-concept.

39

A Change of Clothes
color photolitho; signed F. Gareis; Germany; circa 1910

The suggestive image on this card inspired its sender to write an unusually imaginative and intimate message, which barely disguises his aroused feelings. The exact message reads:

Dearest Rose
I hope you will like the Postcard this week, looks rather naughty doesn't it, but I hope it wont be your Ambition to be like her, because I'm afraid it would be like Brooks soap, 'wont wash'. Never Mind Old Sport, I dont think you would, would you? She dont Arf look Saucy dont she, I feel as though I'de like to push her over, My word if I caught her bending, I'm sure

she'd want a button sewed on. Aint I getting pollyfrananeous at my time of life, dont try to say that word or else you'll be bad. Give my love to Lizzie and Children and Kiss young Winnie for me, with the fondest love with heaps of Kisses Yrs Bert xxxx
(added note) Look at his Pluckett hole at the Back, saucy aint it. You know us men know how to dress if we like.
(added note) My word Rose isn't she a treat. She looks as though she wants to be a little Broad round her narrow doesn't she xxxx

I'll Cry for Mother!
color photolitho; from a series; Germany; post-1905

Adults as infants. He steals her bottle/milk/breast.

Pursuit
chromolitho; from a series; US; postmark Saranac, Mich. 9/7/1909

This image captures with perfect clarity the old phrase 'a skirt pursued by a pair of pants'.

40

Cornucopia
photograph; 4th of a series; Germany; post-1905

German children go to school for the first time with a paper cone filled with sweets.

Japanese Babies
collotype; Japan; K.B. Do., Kobe; post-1906

Little Gods: Pluto, God of Hades
collotype; from a series; France; A. Bergeret et Cie, Nancy; postmark Paris 1/9/1904

Here is one of Bergeret's stock company of street urchins, playing God amongst cardboard flames. The passementerie sash and yard-goods drape are re-used regularly in different contexts on other cards.

41

Fashion: Beyond the Ultimate
photograph; 2nd of a series; Germany; G.L. Co; post-1905

The girl wearing the laundry basket in this witty comment on the outrageously large and flamboyant hats fashionable at this time was apparently one of the most popular models in Germany, judging from the countless cards which feature her.

Out at Last!
photograph; signed Giris; France; A.N., Paris; post-1904

The Oldest Inhabitant
photograph; from a series; US; The Rotograph Co, New York; 1906

Cats were often dressed and posed for postcards; what is not commonly known is that the cats were nearly always dead.

42
Cards with holes are another type of fantasy which requires the participation of the viewer to reveal themselves fully.

Chamberpot
chromolitho; Germany; pre-1905

In the epoch of the chamberpot, this card was undoubtedly better understood and made a more audacious impression, but today we see it differently, as an ironic statement at once vulgar and fine. Its pristine whiteness, simplicity, and almost classical purity of form advance it beyond the merely practical or scatalogical joke. It is almost elegant – idealized – the ultimate potty – perhaps the potty Plato had in mind . . .

Foot Bath
chromolitho; Germany; pre-1905

Here one inserts the index and middle fingers through the holes and tucks them into the bucket (which is wrapped round the card itself) to produce the startling effect of real knees.

> From this bucket, I wish, kind Cinderella,
> To drink, after your bath, the savoury broth.

The interest here is not whether this was considered a joke but that it was considered at all. Even in view of the amazing turns the human mind will take, this message is a fantasy worthy of Krafft-Ebing.

Mask
chromolitho; Austria; A. Schwidernoch, Deutsch-Wagrain; postmark Aix-les-Bains 9/20/1904

Obviously, a real nose is needed here to complete the fantasy image. The small triangles above the eyes are view holes.

43
These nightmarish images reveal a sadism which is startling to us today, but which in its time was taken merely as a joke, on sale for all to share.

Vending Machine
chromolitho; from a series; Germany; postmark Schenectady NY 1/3/1908

This picture might represent the revenge of the machine on a demanding public or, conversely, a projection of our own frustrations caused by a mechanized society, where the machine seems to be a strong-arm punk not only robbing, but insulting and beating us as well.

Silencer
chromolitho; Germany; S.B.; post-1905

Necessary Operation
chromolitho; Italy; postmark Venice 5/18/1913

Between Two Dogs
color photolitho; Germany; C.A. & Co; post-1905

44

Littleton Rd., Aigburth
photograph; England; R.W. Ask, Aigburth; circa 1905

Odd lighting and the peculiarities of one-point perspective turn a very ordinary street into a vision reminiscent of de Chirico. The tiny, dark man is an especially fortuitous focal point. On closer inspection, more people and the familiar signs of life are revealed, rousing us from the surreal and returning our perceptions to everyday reality. The effect is the opposite of that produced by *Group Portrait* (p.63).

Hannover, Zeppelin by the New Town Hall
collotype; Germany; F. Astholz, Hannover; post-1905

This publisher wishes us to believe that his photographer had posed his tripod in a rowboat, focused his camera on the Town Hall, Hannover, and poised himself, cable release in hand, ready to click precisely at the moment when the Zeppelin floated into perfect balance with the building and landscape. Many extraordinary photographs were produced by such skill and diligence. Actually, this equally extraordinary photograph was produced quite matter-of-factly in the studio with two stock shots – one of the Zeppelin superimposed over another of the Town Hall. This practice was common and fruitful: fraud became a kind of stealthy magic, producing many wonderful, if surreptitious, fantasies. Unwittingly, the publisher did in secret what later artists, notably the Surrealists, learned to do in public: combine seemingly unrelated elements and present them, *fait accompli*, for our interpretation.

Eastbourne, Parade and the Wish Tower
collotype; England; printed France; postmark Eastbourne 5/9/1910

A study in alienation or just an ordinary viewcard showing vacationers out for a stroll? The seemingly posed randomness of the people and the strange, simple emptiness of the landscape suggest qualities often found in so-called 'primitive' painting.

Graveyard
photograph US; postmark Salem, Mass 8/31/1906

It appears that an enterprising photographer has transformed a commonplace and presumably not very popular view of the local cemetery into a fantasy by drawing some of the inhabitants

directly on the negative in black ink and printing the results. A message by the sender reads 'Tag! U.R.it!'

45

A Trophy
photograph; Rhodesia; Smart & Copley; postmark Kimberley 12/23/1912

Whether this grotesque still life was intended as a joke or as a serious environmental statement is moot. However, considering the colonial postcard publishers' often flippant attitude toward the African natives, it is hard to imagine much local sympathy for elephants. Today this scene shocks us; in its time it could well have been greeted innocently, as 'a curiosity', for even elephants were plentiful in those days.

Percy Hunt
private photocard; England; circa 1910

Who Percy Hunt was or why he made this card, we can never know. It was never sent; there is no written message. It will remain Percy Hunt's private fantasy.

Von Hindenburg's Bunker
photograph; France; circa 1914

The bare facts, candid yet posed, play ambiguous roles in this oddly static scene, void of any human presence. Suspended time, waiting, confinement, all these are implied in the stark airless space lit by a naked bulb. The latter, and the harsh corrugated metal roof, clash with the formal furniture, an ironically 'refined' touch. It is all deadly serious, yet absurd.

Monument
collotype; France; postmark city obscured 7/29/1906

The inscriptions reads:

> Eternally I will thank you, dear beloved little
> thing
> How empty my life will be from now
> on without him
> Goodbye my little Wou Wou
> Tiny
> age 14 June 22, 1904

46
Examples of the retouchers' art: images retouched beyond the usual bounds of realism and into the realm of fantasy.

The Sphinx
color photolitho; Egypt; printed in France; post-1906

We take the Sphinx and the Mona Lisa for granted; they are emblems we have been taught to recognize from childhood as 'high art'; they are cultural clichés. Both are noted for their mystery and justly so, for in some respects they are also cultural myths. Known

by name to most civilized people, regardless of education, but actually seen only by a small percentage of them, they are believed, accepted. What are these famous artifacts *really* like? Can the original possibly supersede its own mythical fame? In this postcard image the blurry retouching and peculiar color only add to our detachment; any note of realism has flown, the mystery of the Sphinx remains unchallenged.

The Mona Lisa
color photolitho; Italy; circa 1910

The 'improved' version of the Mona Lisa reveals both concern and irreverence. With care and affection, her disturbingly moody landscape has been replaced with a cheerful color, her veil is now red, her lips and cheeks rouged. In fact, all the color is drastically heightened and the strange detail removed. With this act, the retoucher has wiped away centuries of accumulated scholarly reverence and pious adoration, trivializing yet humanizing her into his version of a real, if vulgar, flesh and blood woman.

Person
tinted photograph; France; S.O.L.; postmark Palermo 11/19/1927

On French postcards of the 1920s, it was common to show men whose faces were carefully groomed and plucked, with traces of makeup on the eyes and lips. Representations of women with bobbed hair wearing mens' clothes were also commonplace. Even so, the sexual identity of this person is elusive, the retouching and tinting creating an almost perfect ambiguity which approaches androgyny.

47

Easel
color photolitho; Germany E.S.D.

Easel with Painting
as above, with hand-painted area; postmark Margate (England) 5/7/1905

Individually, each of these pictures, collected from different sources several years apart, is an interesting fantasy, and united as a pair, thanks to memory and its instinctive associations, they interact creating new meanings. In the order shown, the giant pansy painting suddenly appears, as in 'before and after': when reversed, the child artist turns magician and makes the pansy vanish. There is an added twist: the child artist, in fact, is an impostor; the painter of the pansy is the sender, also responsible for the message, 'You must fancy it fair Maude. Send me a card.'

48–49
It seems unlikely that thrift could ever be the mother of fantasy, but such is the case here. The thrifty printer, to increase the variety of his line, has made one image serve two purposes.

This reworking of the original material was obviously not intended to be recognized and might not be apparent if the cards were viewed singly. It is the modern collector who sometimes, by accident, finds the before and after versions and combines them to create entirely new meanings.

48

Rolling Chair Parade on the Broadwalk, Young's Ocean Pier in the Distance, Atlantic City, N.J.
color photolitho; US; P.C.D. Co; postmark Atlantic City 8/24/1912

The Same, at Night
as above; postmark Atlantic City 8/31/1916

These scenes are as different as day and night, yet the same. Both must have been on sale side by side in many shops, inviting ironic interpretations, though each is obviously intended to be accepted as 'true'. Today when we combine them we can *pretend* the truth, with odd results. The strolling vacationers remain in place, under sun and moon: the relentless parade of Bath chairs literally never moves. The anthropologist of the distant future might well ponder the meaning of this peculiar ritual: what mysterious force makes life stand still in Atlantic City? Close inspection reveals that the day scene is already highly retouched; hence, the night scene is a retouched retouching. It is interesting how far reality can be altered and still accepted as such.

Cheapside, London
color photolitho; Scotland, Valentine & Sons, Dundee; postmark 4/27/1908

If London Were Venice – Cheapside
as above, no postmark

These before and after views of Cheapside help to trace the process by which the retouch artist transformed an everyday scene into a charming fantasy. If we choose, we can also see it as a metamorphosis which takes place in the instant we look from one scene to the other.

49

Mandolin Player – Moon
chromolitho; Germany, overprinted in English; postmark Coventry 8/23/1906

Mandolin Player – Jack-O-Lantern
as above; postmark Brooklyn 10/30/1908

In this pair the printer's replacement is as inventive as the original artwork. Each is a fantasy in itself; combined, they create a new fantasy of metamorphosis.

Breakers, Atlantic City, N.J.
color photolitho; US; postmark Atlantic City 8/28/1910

Breakers at Asbury Park, N.J.
as above; postmark Asbury Park 8/3/1912

These cards are blanks designed to be overprinted with whatever place or message the local dealer thought appropriate. They were a simple way to increase the variety of one's stock without the bother of hiring a photographer and printer to produce authentic views. The intense irony of seeing identical breakers from different places causes amusement at the printer's audacity, born of indifference, and mock amazement at the miraculous recording of such a phenomenon. Oddly enough, just as any image is a symbol of the real object it represents, these identical waves, despite the motives which caused them, become a symbol and archetype of all waves at all seaside resorts. People instinctively bought symbols to send, and ultimately they were right; they knew the purpose of postcards.

50

The Letter O
color photolitho; from a series; Germany; post-1905

Alphabets of all kinds are a favourite postcard convention, and many more subtle variations on the letter 'o' exist than this. It is its crudity which provides the primary interest, however, an arbitrary rustic circle framing an absurd eighteenth-century minuet.

This is How Watermelons Grow in California
color photolitho; US; Edward H. Mitchell, San Francisco; circa 1910

Unlike so many fantasies popular in America, which were produced in Germany and overprinted with messages in English, montages of exaggerated produce were indigenous to the United States. The idea first appeared around 1907 and is unique in that it survived the First World War and has remained popular in various forms to the present day, when updated versions can still be found across the country. The early types were as common in America as 'multiple babies' were in Europe and have endured in popularity much as the comic seaside postcard has in England.
 In 'The Land of Plenty', these cards expressed a sense of local pride which often took the form of good-humored boasting. They extended the verbal fantasy of the 'tall tale' by providing proof in the form of a picture; after all, seeing is believing. This kind of grass roots humor was most often exchanged between people in small towns, perhaps by those who might not have been great storytellers but who recognized a good joke and could add a brief comment of their own on the back, encouraged by the audacity of the ready-made image.

A Stormy Day (*Un Jour de Tempête*)
color photolitho; Belgium; Edition V.G., Brussels; post-1906

This scene, remarkably retouched, is transformed into a mute, dream seascape worthy of Magritte. The streetlights, in mad perspective, seem determined to tease our sensibilities. The wave, so ambiguous, could be an errant cloud, a silent explosion, a phantom.

Rye and Camber Tram Passing Golf View, Sussex
color photolitho; England; A.H. Homewood, Burgess Hill, Sussex; circa 1905

A nicely surreal companion to the above 'Tram' provides in irony what 'A Stormy Day' supplies in poetry. Is the theme of this pair, Pollution *v* Purity? It is a card which allows us reverie: what, for example, must it be like to live at Golf View, in the midst of nowhere, engulfed regularly by clouds of smoke from the Rye and Camber Tram as it passes the doorstep, enabling one to tell the time by the distinct change in atmosphere?

51

Entente Cordiale, Produced in Butter
tinted photolitho; Scotland; Valentine & Sons, Dundee; 1908

Surely there is nothing so banal as butter pats designed to be spread on breakfast toast. Contrast this to the 'Entente Cordiale', possibly butter's finest, most visually expressive hour. Butter Art: a wave of the future? Certainly the youth of today has much to learn from such past glories. In point of fact, the Canadian Pavilion at the Franco-British Exhibition of 1908 was a veritable salon of creamery creations, where one could view an entire table setting with bud vases, leaves and rosettes made of butter, a harp and a pitcher of butter, and baskets of butter straw containing butter daffodils, roses, lilies and maple leaves. There was 'God Save the King' and 'La Marseillaise' inscribed in butter note by note, as well as a butter bust of Edward VII. And the *pièce de résistance,* the rich and golden, if not deathless, masterpiece reproduced here.

The Little Lone Coon
color photolitho; photo by Landor; Germany, for Wrench, London; circa 1903

Stately Royal Palms, Florida
color photolitho; US; Curteich, Chicago; postmark St Petersburg, Florida, 6/13/1946

The main subjects of this picture are the highly retouched, striped trees, which seem invented by the retoucher, the two girls holding hands, who appear to be superimposed but in fact are not, the mysterious bush isolated at the end of the path, and the path itself, pointing the way in strict one point perspective. Suggested titles are 'Babes in the Woods' and 'A Child's Garden of

Phalluses'. It should be noted, in view of this black and white reproduction, that the bush at the far end of the path and shorts worn by the girl on the left are exactly the same shade of bright pink. This choice negates the obvious perspective of the path, giving the whole picture a flat appearance, contradicting its composition, which indicates great depth. The trained artist attempts to use his colors for a specific purpose, whether it be for harmonic, psychological or compositional reasons. The untrained artist, who gives us so many unintentional fantasies, chooses colors spontaneously or practically. We can interpret these choices as if they had literary meaning and often are forced thereby to consider, say, what relation the bright pink bush has to the bright pink shorts.

Alligators
color photolitho; Germany, for US; post-1907

This image of primeval terror, coupled with 'Palms', contributes even further to the list of possible interpretations. The absence of the usual conventional and civilized printed title, such as 'An Alligator Farm, Jacksonville, Florida', only adds to our uneasiness. The meaning of this image is enriched by the mystery of not knowing the specific facts which we rely on to settle our minds. Literally, we are in a strange land, 'in the dark'.

52

Tip to Tip
color photolitho; Germany; pre-1905

52–53

Bathing Scenes
tinted collotypes; from a series; France; post-1904

The act of creating these delightful photomontages is a fantasy in itself whereby the artist has populated photographs of deserted seaside places with bathing girls snipped from other sources. We sense the atmosphere of unreality because of the limitations of his technique which creates odd static poses, conflicting shadows, or lack of them, and inconsistencies of perspective. By recognizing and experiencing these 'limitations' a deliciously ironic conflict develops between the 'real' world which we are meant to accept and the 'fake' world we discover for ourselves. We are presented with the amusing option of being able to see both worlds and allow ourselves to be fooled by them. Our act of looking and believing becomes an imaginative experience, a fantasy. Viewing all the cards in the series together reveals another kind of fantasy; a visual game. Since the artist used the same poses on many of the cards, the object is to spot the same pose on as many cards as possible in the series.

54

All of the cards on these two pages represent fantasies, interesting in themselves as pictures, but also in their juxtapositions. They have been

combined in more or less interrelated pairs for reasons of composition, subject, and irony, but also by instinct and whim. An interesting exercise in fantasy-making is to combine different, seemingly unrelated images – the hermit with the mirror, the rock with the nude, Pernette with the rock, the nude with Pernette and so on – allowing our reactions to jolt our normal perceptions.

The Hermit Amidst His Works
collotype; France; ELD; 1908; postmark Rochers Sculptés Rotheneuf, 29 July 1911

At the age of forty, L'Abbé Adolphe-Julien Fouéré began immortalizing the legendary exploits of the colourful Rotheneuf clan, active as pirates in the mid-sixteenth century. He chose as his materials the very rocks where they had lived, a rough promontory between the two deep chasms called Heaven and Hell on the coast of Brittany, between St Michel and St Malo. For the next twenty-five years, helped by one assistant, he allowed the rocks themselves to suggest a shape for the story he wanted to tell, covering the area with hundreds of images: visions of the Rotheneuf men, their ladies, the wild band of sailors, warriors, magicians and brigands who were their henchmen, animals, grotesque demons and the sea monster which legend says devoured the last surviving Rotheneuf during a shipwreck. 'The Hermit', as the sculptor was known in town, achieved a perfect meeting of form and content by carving the legend out of its own stone. This postcard suggests the strangeness of his fantasy vision where figures emerging from the rocks seem to materialize like ghosts.

Musée Grévin, Distorting Mirrors
collotype; France; circa 1910; postmark Paris 11/4/1926

The Musée Grévin in Paris, a famous waxworks with a tiny theatre where daily magic shows are presented, is virtually unchanged from the time this card was made. Its most important attraction is a pure Belle Epoque entertainment, perhaps unique in today's over-restored world. A small audience is invited to stand in the center of a hexagonal-mirrored room. When the doors close, the wall panels slowly revolve to music transforming the room into several completely different scenes – an oriental palace, an Egyptian temple, a grotto – each reflected to infinity in the many mirrors. At one point the ceiling itself revolves, lowering huge silk butterflies covered in tiny lights. The verso bears a discreet credit: 'M. Bonnard, Fabricant de Glaces deformantes, Rue du Chemin Vert, Paris'.

Picturesque Hollows (*La Creuse Pittoresque*)
collotype; France; message dated 9/11/1911

The message reads: 'Souvenir of my walk in Creuse'. The title reveals a play on words, since Creuse is an area of France as well as the word for 'hollow'.

Reclining Nude
collotype; France; clubs logo CCC&C; post:1904

The lady is atypical of the production of this publisher, noted for endless series of locomotives. It is also unusual on a card of this period for the model to be shown without a bodystocking, however scrupulously retouched.

55

Matron
collotype; Saxony, for Lofthouse Crosbie England; circa 1910

Sometimes, through close inspection, we learn to take exception to the unexceptional. At first glance, Matron, with her cat and sewing basket, seems unexceptional indeed. Not Matron Ford or Matron Fiske, just Matron. We wonder why this anonymous woman was immortalized; what is her story? Simplicity is often baffling – any detail becomes significant and we cling to it in an effort to understand. Glancing again, noticing the overcast day, our eye is drawn across grass and gravel drive to the dense ivy surrounding the dark windows of her 'institution'. We pause. The windows are open. Matron knows what we might glimpse in those darkened rooms. She sits stiff, silent and determined, between us and revelation. Her fixed stare and that of her cat become alarming. And, yes, that sewing basket . . . We become involved in a mystery. Did Matron do it? If so, what did she do?

Massage at Vichy
collotype; France; post-1914

Spas such as Vichy produced many cards, among the most unusual being those depicting the various tortures suffered by their guests in the name of health.

Pernette, in training on his motorcycle
collotype; France; C.M. Paris; post-1904

This exciting action shot is in fact carefully posed; close inspection reveals traces of a kick-stand and another support which have been retouched-out. A long time exposure might account for M Pernette's glazed expression.

Napoleon's Camp Bed
collotype; France; post-1904

A minimal statement and a lesson to the impatient. Remarkable that the empty bed in its bare niche, both receding in one point perspective, vanishing point marked by an indecipherable plaque, could have been photographed at all, and with such daring simplicity. Upon discovering that 'Napoleon Slept Here', we begin to fill the emptiness with our own imaginings, altering our attitude toward the image and enhancing it with applied ideas.

56
Much of what we consider erotic is the product of imagination, whether our own fantasies or

someone else's of attaining impossible desires, as well as memories re-constructed with happy endings. The pin-up is a classic erotic stimulus, unlocking psychological doors and tripping sensual switches, a tangible fantasy-substitute for the real erotic object. Its medium is suggestion, calculated concealment and revelation: the ideal tease, providing the promise of fulfilment without the eventual distraction of disappointment. Note: erotic postcards can usually be dated only approximately for they were rarely sent through the mails and remained unused, preserved in the jacket pockets of male travellers.

Glance
photograph; from a series; France; A. Noyer; circa 1920s

Of this unusual series of close-ups, the sidelong glance is especially appropriate coupled with its object, the mountainous biceps of Sandow, 'The World's Strongest Man'.

Bather
tinted photo; from a series; France; Super; circa 1920s

This bathing costume, unless designed specifically for this pin-up or for a sexy revue, serves no practical purpose in the respectable everyday world other than as an antidote to everyday respectability.

Girl with Herma
photograph; from a series; France; JB; circa 1920s

The girl is flirting with a herma, or Greco-Roman decorative column, usually topped by the head of Hermes. In this case Hermes has been changed into a faun. Significantly, the ancient Herma was often equipped with genitals, though this studio prop replaces authentic detail with discreet ivy. The girl, slightly less proper, is also altered.

57

Sandow
photograph; from a series; England; Rotary Photo; circa 1905

The Prussian bodybuilder, Eugene Sandow, had a celebrated career performing feats of strength around the world; his many extant poses wearing only a fig leaf must qualify him as the foremost male pin-up of the day. Here, his virtually disembodied biceps is presented as a subject worthy of awe, and, undoubtedly, erotic fascination.

Woman and Horse
photograph; 3rd of a series; Prussia; G.G. Co; post-1905

This idea has been on people's minds from the ancients, to Catherine the Great, to the man who conceived this photograph.

Living Marble (*Lebender Marmor*)
photograph; 4th of a series; Germany; PHR; circa 1920s

Living statuary and tableux vivants were popular entertainment in the theatre and night clubs throughout this period. This twenties example employs nudity but harks back to the nineteenth century's ruse of disguising erotica by calling it art.

58

Jungfrau (*Virgin*)
chromolitho; Switzerland; post-1906

Man, with his instinct for creating metaphors, has always enjoyed finding human and animal images in nature: a bull in the stars, a face in a cloud, and, in this instance, a beautiful young woman in a mountain. One cannot know for certain how long some of the Alps have had their names, but surely the Jungfrau has been a virgin for centuries and the subject of many tales. An anonymous Swiss artist with knowledge of his folklore and a keen imagination has invented this remarkable image which poses many interesting questions. Is this mountainous maiden being discovered, explored, or conquered by the tiny men? Upon waking suddenly, would she idly crush them like so many ants or encourage their search? We sense the peril and excitement of the climbers' urge to conquer, but wonder why the woman is so large and why the men are so small. Is this virgin really asleep on her bed of snow? The feeling of night with its heavy sky, the sense of sleep, and the abandon of dreams is pervasive. The moon spies on the scene and sheds light, but not enough to illuminate our questions. Is this image the virgin's dream, the mountain-climbers' fantasy, or a dream-fantasy of our own? Could we be merely voyeurs like the moon?

59
Unmistakable sexual symbols are found on cards where they were not consciously intended. Ironically, today's interpretation of the unconscious meaning becomes, for us, the more interesting subject of the card and the actual mountain-peak, cave or tower loses its original importance.

Ascending a Peak
chromolitho; Switzerland; Edition Photoglob, Zurich; post-1906

Could these be the little explorers of the Jungfrau stalking another sort of conquest?

The White Lady of La Jolla, California
color photolitho; US; I.L. Eno, San Diego; post-1907

White/virgin-Lady/proper. Dark-cave-water-opening-light. To leave? To enter?

The Sugar Loaf *(Le Pain de Sucre)*
tinted collotype; France; post-1904

The inscription reads

> The widow of General Leclerc Desnoëties,
> concerned with the lot of seafarers
> and their children, erected this
> monument on a point where it prevents
> misfortune and signals danger.

This fantastic erection with its ironic name and
inscription exists in the midst of everyday
reality — the man, the fence, the door, the hilltop
near Le Havre. On our attempt to understand
the picture as a whole, we are forced to make
sense of chance juxtapositions, the collision of
fantasy and reality. Our usual logic is tempered
by imagination. What is the relationship of the
little man to the giant phallus? Of what
significance is the fence? And the mysterious
door — what could it conceal? The scene is
enveloped in subtle watercolour tinting which
unifies the picture visually but also adds an
ironic edge to its interpretation and creates a
distancing effect, placing the whole scene
somewhere outside actual time, into that of a
dream or an imaginary past.

60–61
Using shapes which suggest other shapes,
these composed heads-and-skull scenes create
visual double meanings or puns. Their spirit is a
kind of formalized game; the visual pun, a play on
images, reverberating before our eyes much as
the verbal pun plays on words in our minds.
The sixteenth-century Italian painter, Arcim-
boldo, specialized in faces composed of flowers,
fruit, vegetables, animals and landscape
elements; in our own time, Dali has used similar
devices. But it was the postcard artist who
adapted the composed head to the popular arts,
with his usual vigor. The death's heads are
suitably morbid, but usually with a sentimental,
moralistic tone indicated by such titles as 'All is
Vanity', 'The Parting' and 'Aujourd'hui rose,
demain . . .' The faces composed of writhing,
lightly draped or nude women were unabashedly
erotic, and, as their bodies often formed portraits
of contemporary statesmen and celebrities, they
could well have raised eyebrows.

60

Pierrot's Love
photograph; Germany; P.F.B.; circa 1910

Farewell Letter
*photograph; Germany; P.F.B.; postmark London
10/20/1909*

Together Until Death Do Part
*photograph; Prussia, for Ettlinger & Co, London;
circa 1910*

61

A Rake
photograph; Germany; P.F.B., circa 1910

The Great Conqueror
*photograph; Prussia, for Ettlinger & Co, London;
circa 1910*

Mephisto
photograph; Germany; mouse logo; circa 1910

One might muse over the visual equivalents
which might occur in this image; horns/arms,
eye/ear, nose/thighs, mouth/face, hair/beard.

62–63

All kinds of imaginings-made-visible are the
domain of the fantasy postcard. Nightdreams,
daydreams and pipedreams become manifest;
and it should be noted regarding the latter that
the concept of 'visions' while smoking originated
in the opium den.

62

It was a Dream
*tinted photograph; France; Prince; postmark
Paris 7/30/1906*

Cigarette Girl
tinted photograph; 5th of a series

Daydream
*tinted photograph; Prussia, for Ettlinger & Co,
London; postmark Durham 7/30/1912*

63
These dream images could only be termed
hallucinatory.

Lovers and Poppies
*tinted collotype; Germany; postmark Willow
Hill Pennsylvania 8/15/1907*

Rolling Tire
*collotype; France; message dated Rouen
4/19/1920*

Appropriately, this is an advertisement for
Bergougnan tires.

Submerged Group
*collotype; Austria; Ferd. Mohr, Baden b.
Wein; 1909*

What seems to be a strange baptism ceremony
officiated by a waiter is actually a group of
vacationers 'taking the waters' at Baden, near
Vienna. A similar dip, featured at Loëche-les-
Bains in Switzerland, provided patrons with
floating trays shaped like lilypads on which they
could play chess, read, or have tea.

Group Portrait
*photolitho; Germany; Schmidt & Böttger,
Lubeck; circa 1930s*

Close inspection reveals that everyone pictured
here is a midget, all cast members of Schaefer's
Lilliput Revue, a German company which toured
Europe in the twenties and thirties. An earlier
card shows the company in flapper dresses and

tuxedos; another, in their performance costumes
as clowns, acrobats, shepherds and
shepherdesses, jockeys, orientals, and ballerinas.
A later view shows them walking through a tiny
town built to their scale, identified as 'The Fairy
Tale Town of Lilliput', dressed as the mayor,
guardsmen, the policeman, the postmaster,
shopkeepers and townsfolk.

64
The images on these pages are pin-ups whose
erotic intentions are masked. When one
considers the veiled erotica of classical nudes
frolicking in the fine art of the period, it is not
surprising that this convention filtered down to
the popular arts. What is surprising in the case
of these cards is the strange form the disguise
takes.

The Five Senses: Sight
*collotype; from a series; France; Bergeret,
Nancy; Cliché G. Morinet, Nantes; postmark
Nantes 2/10/1909*

The intention here is presumably serious, yet
the absurd realism of the bust reduces the
traditional idea of sculptured portrait busts to
absurdity.

Arabian Woman with the Yachmak *(sic)*
*collotype; Algeria; Behar et Fils;
post-1906*

Both elaborately veiled, and totally nude,
ethnic women were not uncommon postcard
subjects and often the latter were daring
pin-ups rendered more acceptable by their aura
of 'foreigness'. Here the two extremes collide,
creating a mysterious and provocative image
at once reticent and bold.

Doll Couple
collotype; Germany; K.S.P.M.; pre-1905

In a period when dolls could be naked but
humans could not, when sex education usually
meant 'Mommy has long hair and Daddy has a
moustache', the audacious postcard artist,
simply by fixing real grown-up faces to naked
dolls' bodies, caused this strange mating of the
innocent with the erotic, of the nursery with the
bedroom, of memories of childhood past with
present-day adult fantasies.

65

Cast up by the Sea
*photograph; signed Hedrick; US; postmark
Montery, Cal, 8/23/1917*

Vacationers at many seaside resorts around the
turn of the century, recalling their own early
attempts with tin pail and shovel, delighted in
the expertise and ambition of sand sculptors
who daily set about creating Everyman's
ultimate sandcastle. Subjects were usually
'serious' and ranged from animals and still lives,
to military and political themes, to elaborate
neo-classical friezes, and such occasional

exceptions as a full-sized automobile. The
Sphinx was popular in France, and at Atlantic
City Dante's profile could be seen sandwiched
between those of Garfield and McKinley.
Titles further revealed pretensions to fine art:
'The Last Message', 'The Ancient Mariner', and
'A Few Grains of Sand'. The woman with child
pictured here was usually entitled 'Sleep' and
accompanied by a quote from Shakespeare,
but 'Cast Up By The Sea' is a dramatic choice,
more in keeping with the morbid sentimentality
of much contemporary 'official' art. Whether
this ample sand goddess of mysterious origins
and nubile vulnerability is the victim of drowning
or merely asleep is left open to question. Today
we see her as an ephemeral seaside pin-up
dignified by the aura of fine art, but in danger of
being swept away by the next high tide.

Greetings from the Mudbaths
color photolitho; Germany; J.F.K.B.; pre-1905

This patient's pose and remarkable disguise
suggest that her ailment is nothing more
serious than a case of *la nostalgie de la boue.*

Beauty and the Beast
photolitho; US; post-1907

The protagonists in this fantasy — the woman,
the lobster, the steel bed, the seascape, the
blank, undefined room, the evocative title —
defy logical analysis like a puzzling dream, but,
in true surrealist fashion, encourage reverie.
Hundreds of meanings suggest themselves to
us. There is no single correct interpretation, we
must draw our own personal conclusions.
Note: wild breakers and rough seas were
extremely popular postcard subjects during
this period. Perhaps these cards captured the
mixed emotions one experiences when
confronting ungovernable and destructive
power; the excitement and fear we feel in the
face of unrestrained nature.

Entrée
*color photolitho; from a series; Saxony;
Arnochrom; post-1905*

Alternate courses might be *Chou Garni* or
La Poule sur la Plat.

66–67
The population explosion shown in these
montages occurred in the era of the big family,
when procreation was considered the highest
self-expression of the human race, the healthy
outcome of lovemaking, the ultimate goal of
marriage, and sometimes its premature cause.
These are not the classic cherubim which flew
across cathedral ceilings. They are common
urchins, well-suited to a popular art: earth-
bound, hyperkinetic and generally
undisciplined, though toilet-trained, as all
those potties evidence. They are often shown
'arriving' — hatching from eggs, sprouting from
cabbages, dropped in chimneys by storks,
spawning like minnows, delivered in baskets
like produce, in short, perpetuating the